IMAGES
of America

CEMETERIES OF
YAVAPAI COUNTY

CITIZENS CEMETERY

Citizens Cemetery was founded in early June 1864 with the burial of Colorado legislator Joel Woods. Established on public land east of Prescott and southwest of Fort Whipple, the cemetery has been known at various times as "Town Cemetery", "City Cemetery", "Prescott Cemetery" and "Citizen's Burying Ground". The name "Citizens Cemetery" first appeared in print in January 1872. The United States deeded the

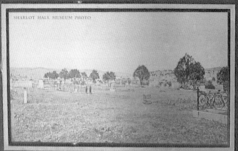

land to Virginia Koch in 1876. After her death, it was purchased by T. W. Otis and George Tinker and their wives. On October 13, 1884, the land was transferred to Yavapai County. Burial lots were "leased" for 99 years at a cost of $2.50. Interments continued on a regular basis until 1933. The cemetery contains the graves of more than 2,500 persons and approximately 600 markers. Citizens Cemetery is populated with a wide spectrum of individuals who settled and developed central Arizona during the late 19th and early 20th centuries.

In 1934, a Civil Works Administration project resulted in the construction of an uncoursed fieldstone and concrete masonry wall which enclosed the 6-1/2 acre cemetery. By that time, the entrance to the cemetery had been moved from the south end to the north end. Later, the north wall was demolished for the widening of Sheldon Street. A new stone wall topped by a fence and a new entry were constructed in 2000. Citizens Cemetery is listed in the National Register of Historic Places.

FUNDED BY THE CITY OF PRESCOTT

This historical marker now graces the entrance to Citizens Cemetery in Prescott. It is one of a number of similar markers erected at historic sites by the city's Historic Preservation Department.

ON THE COVER: Citizens Cemetery in Prescott, Arizona, is pictured in 1963. At that time, the cemetery was in a state of neglect and disrepair that lasted into the 1990s. (Courtesy of Sharlot Hall Museum.)

IMAGES
of America

CEMETERIES OF
YAVAPAI COUNTY

To Judy,

Thank you !

Parker Anderson

ARCADIA
PUBLISHING

Published by Arcadia Publishing
Charleston, South Carolina

Printed in the United States of America

Library of Congress Control Number: 2013932918

For all general information, please contact Arcadia Publishing:
Telephone 843-853-2070
Fax 843-853-0044
E-mail sales@arcadiapublishing.com
For customer service and orders:
Toll-Free 1-888-313-2665

Visit us on the Internet at www.arcadiapublishing.com

To the men and women who maintain and care for cemeteries, who recognize that they are not only reverent burial places for our loved ones, but also major historical and cultural sites

CONTENTS

ACKNOWLEDGMENTS

A book such as this is never accomplished without the help and input of many people. In particular, I wish to thank Pat Atchison, founder of Yavapai Cemetery Association, and her daughter Ann Waterhouse; Julie Holst, Bob Bakken, and the Board of Directors of Yavapai Cemetery Association; Colleen Holt of Jerome Historical Society; Cindy Emmett and Jerry Wombacher of Clarkdale Historical Society; Julie Simon, steward of the Congress Cemeteries; Shirley Ballew, steward of Skull Valley Cemetery; and Neal Du Shane of Arizona Pioneer Cemetery Research Project (www.apcrp.org). A special thank-you to my friend Jody Drake for supporting all my endeavors. Except where otherwise noted, all photographs are by fellow taphophile David Schmittinger.

INTRODUCTION

The Territory of Arizona was created from part of the land that was ceded from Mexico to the United States at the close of the Mexican War of 1846–1848. For years, what is now Arizona laid quiet and dormant, inhabited mostly by Apache Indians and a few scattered miners.

In 1863, thanks to lobbying by men such as Charles Debrille Poston and others, the Organic Act of 1863 was passed by Congress and signed by Pres. Abraham Lincoln on February 24, 1863, creating the official Territory of Arizona. Pressure to create the Territory was compounded by Confederate attempts to claim the land during the Civil War.

The first governor's party arrived in the Territory to set up the capital and the first Territorial government. They settled along the banks of Granite Creek and named the new village Prescott in honor of the famed Boston-based historian William Hickling Prescott, who had written extensively on South America and Mexico. In the first governor's party were Gov. John N. Goodwin, secretary Richard C. McCormick, Henry W. Fleury (who would hold several different offices), and others.

The first Territorial legislature divided Arizona up into four counties, with Yavapai County (named for the Indian tribe) being the largest, reaching to the Utah border to the north. Eventually, the counties of Coconino, Apache, Navajo, and Maricopa broke off from Yavapai County, partly due to Arizona citizens who were increasingly frustrated at having to travel so far to Prescott whenever they had business in the county seat or were called for jury duty. The final borders of Yavapai County were drawn in 1891, as they remain today.

Arizona grew rapidly with mining. In territories such as this, many tales can be told from the early-day cemeteries. Burial grounds were a needed commodity as people began to die in the new territory. All told, there are over 150 cemeteries in Yavapai County alone.

This book does not endeavor to cover all of these burial grounds. Rather, it is our wish to tell the stories of Yavapai County citizens through the most interesting and historical cemeteries. Most were traditionally located on the outskirts of town although, in cases such as Prescott itself, the towns eventually grew around the cemeteries.

With a few exceptions, these cemeteries follow the Christian tradition of having the dead buried facing east, in compliance with Christian teaching that Christ will return from the east, and those buried in Christ should be facing him in the Resurrection. This tradition has become less common in recent years, with Christian beliefs having evolved to teaching that the soul is dispatched to heaven or hell upon dying, rather than on the forthcoming day of Christ's return.

Unlike many areas of the nation, the oldest cemeteries in Arizona are surprisingly nonsectarian, with very few genuine church cemeteries in the early days. Catholics, Protestants, and Jews were usually buried together in the same graveyard. There was limited racial segregation in some, but not all, pioneer cemeteries.

The cemeteries of Yavapai County are the place to start when the researcher begins looking into Arizona burial grounds, for Yavapai County is truly where Arizona began.

One

CITIZENS CEMETERY

Citizens Cemetery was established on 6.5 acres of land in 1864, the same year Prescott became the Territorial capital of Arizona. At that time, the cemetery was considered to be far from downtown Prescott. The first recorded burial here was that of Joel Woods, a state legislator from Colorado who was probably visiting the new territory. In those days, people were often buried in the area where they passed away. His grave is unmarked.

This is the oldest official cemetery in all of Arizona, and any research of Arizona burial grounds must begin here. While over 3,000 graves are believed to be within its walls, there are reliable records or tombstones for only about 1,000 of them. Its residents include the rich and the poor, the famous and the infamous, and the forgotten. Large areas of vacant land hide many unmarked graves. Citizens Cemetery was purchased by Yavapai County from private owners in 1884. Burials stopped in 1933 when it was determined the grounds were full.

After that, Citizens Cemetery fell into many years of neglect, overgrown with weeds and seriously damaged by vandals. In March 1996, Pat Atchison formed the Yavapai Cemetery Association, and she, along with her husband John and a group of dedicated volunteers, worked tirelessly to clean up and restore the cemetery and document graves and help those who are seeking to locate ancestors who are buried in Citizens Cemetery.

Today, Citizens Cemetery is a fine, well-cared for burial ground for the many Arizona pioneers who are buried here. The Yavapai Cemetery Association continues its work here to this day and may be contacted at ycacitizens@gmail.com.

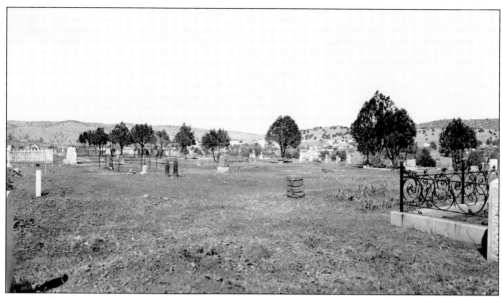

This is Citizens Cemetery in the 1930s. By this time, large open areas obscured the existence of unmarked graves. It was not long after this that burials in the cemetery were discontinued. (Courtesy of Sharlot Hall Museum.)

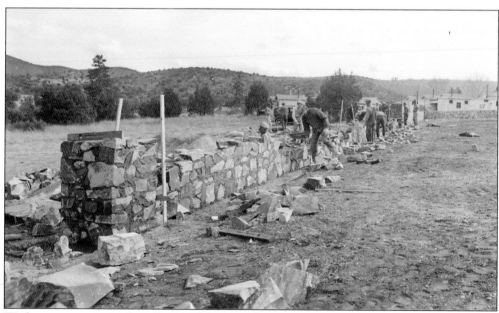

Workers construct a rock wall around Citizens Cemetery in 1934. This was part of the Works Progress Administration (WPA) building program, sponsored by the US government to put citizens back to work during the Great Depression. (Courtesy of Sharlot Hall Museum.)

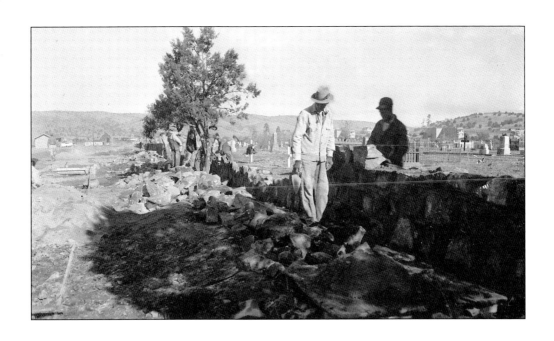

The 1934 rock wall still stands around the cemetery as a testament to time, except for the entrance portion, which was removed in later years for the widening of Sheldon Street. These photographs are the oldest known images of Citizens Cemetery. (Courtesy of Sharlot Hall Museum.)

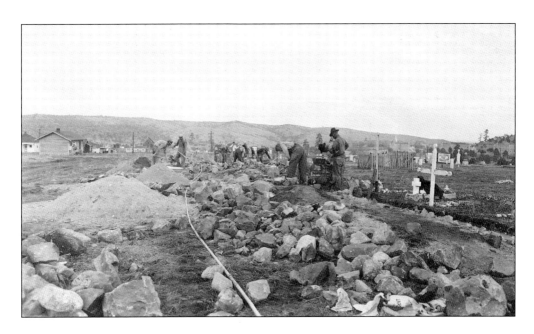

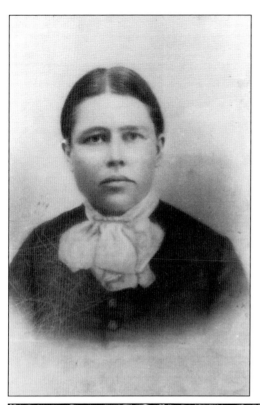

Catherine Hoagland and her husband, David, were early pioneer settlers along Lynx Creek in the late 1800s. Their young daughter Angeline died there and was buried along the creek near their home; she is discussed in chapter nine. Family members say that Catherine was part Cherokee Indian. (Courtesy of Carol Wilbur.)

Pictured is the grave of Catherine Hoagland, in a plot with her daughter Julia and other family members. Catherine's husband's burial place is unknown at this time.

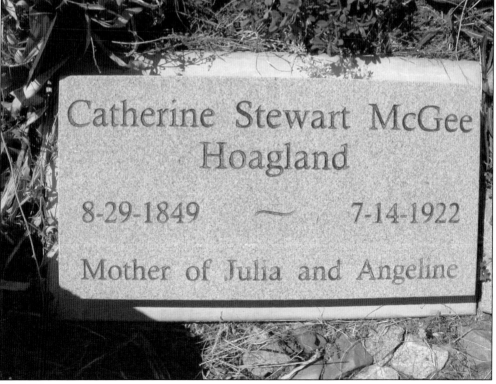

Catherine Stewart McGee Hoagland

8-29-1849 ~ 7-14-1922

Mother of Julia and Angeline

Unlike her sister Angeline, Julia Hoagland Hicks grew into adulthood and had four daughters of her own. This undated photograph shows Julia as a young girl. (Courtesy of Carol Wilbur.)

Julia Hicks is buried in the family plot next to her husband and mother. The grave is cared for by present-day family members.

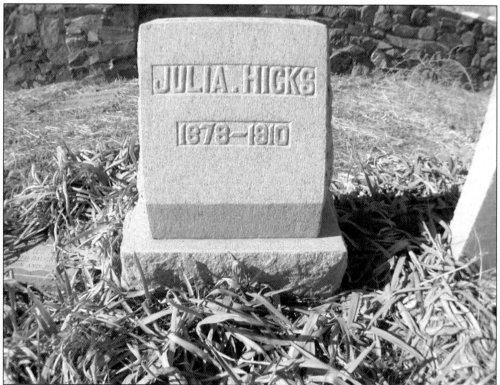

The passage of time, the elements, and vandals have done much damage to tombstones and markers in the cemetery. Some have been repaired in recent years by the Yavapai Cemetery Association, while others are beyond repair.

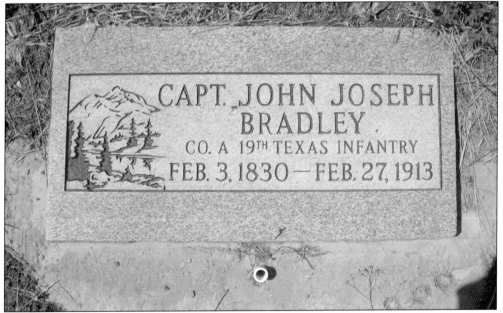

A handful of Civil War veterans are interred at Citizens Cemetery, including John Bradley of the Confederate army. His grave is cared for by local Civil War historians who, like many such historians, are sympathetic to the Confederate cause.

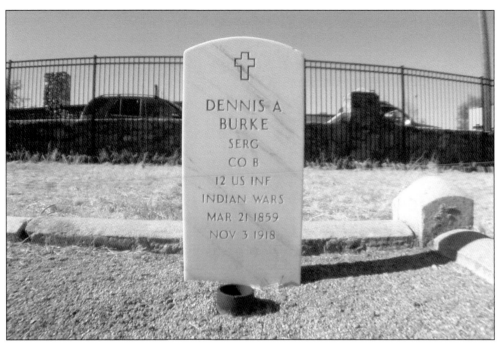

Prescott mayor and businessman Dennis Burke is perhaps best remembered for the Hotel Burke in downtown Prescott. It was later renamed the Hotel St. Michael, which still successfully operates.

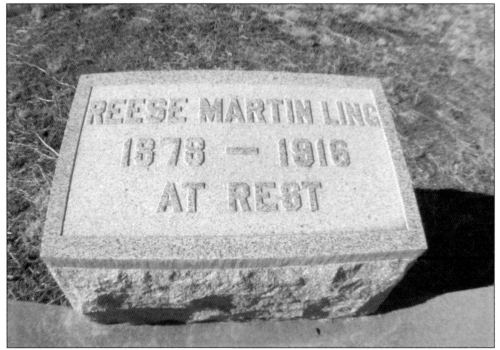

Reese M. Ling was a prominent Prescott businessman and member of Prescott Elks Lodge No. 330 Benevolent and Protective Order of Elks (BPOE). He played a major role in securing the financing to construct the legendary Elks Opera House in the downtown.

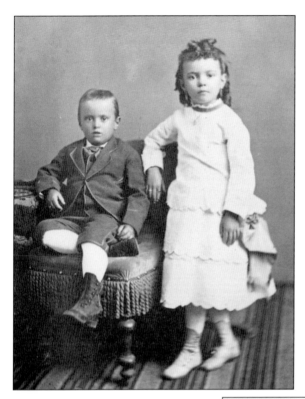

Albert and Henrietta Behan are seen here as children in a photograph from 1877. They were the children of lawman John Behan, who would become sheriff of Cochise County and enemy of Wyatt Earp. The Behan family resided in Prescott early on, where Henrietta died at the age of seven shortly after this photograph was taken. (Courtesy of Sharlot Hall Museum.)

The worn and weathered tombstone of Henrietta Behan in Citizens Cemetery appears here, far away from the grave of her famous father in Tucson. Her brother Albert grew into adulthood and is buried in the Pioneers' Home Cemetery.

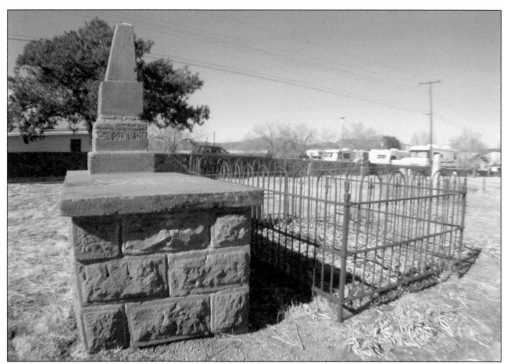

One of the mysteries of Citizens Cemetery is this large stone crypt, which features a hand-carved inscription that simply reads, "Nelson Lane," with no year of death. Yavapai County historians have been unable to locate any records that a person by this name ever lived or died in the area, though he obviously did. That this man was given such a large monument only deepens the mystery.

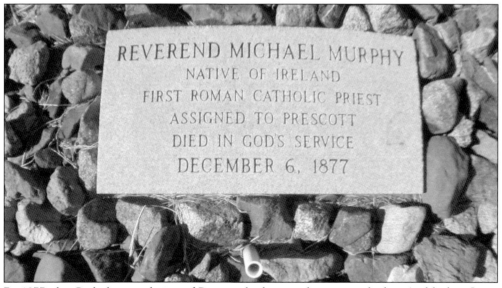

By 1877, the Catholic population of Prescott had grown large enough that Archbishop Jean-Baptiste Salpointe of Tucson sent Fr. Michael Murphy, a native of Ireland, to establish a church there. Father Murphy arrived in Prescott in October 1877, reportedly suffering from consumption at the age of 37. He celebrated Mass a few times but passed away two months later on December 6, 1877.

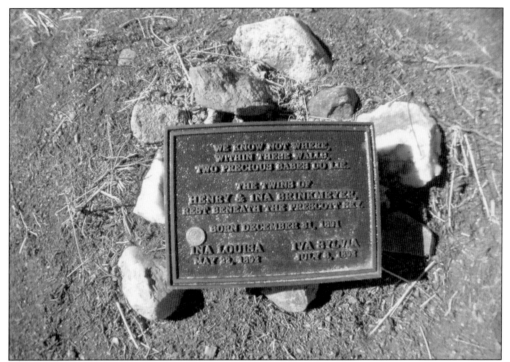

There are hundreds of unmarked graves in Citizens Cemetery, some of which are identified on an old existing cemetery map, but others are lost to history. Many who died in those early days are surely buried here, but the records are lost.

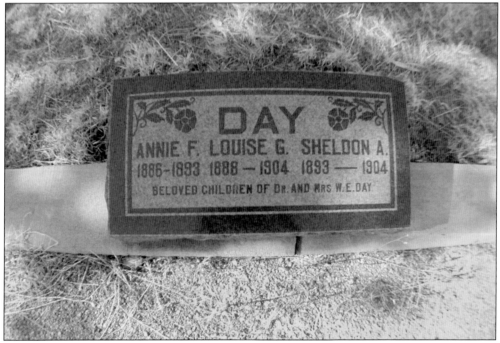

Dr. Warren E. Day was a prominent Prescott physician and pioneer. He tragically lost three children at young ages. They are buried here, but their father is buried in another cemetery.

Charles Genung, one of the earliest and best known pioneer settlers in Yavapai County, worked as a miner and road-builder in the southern area of Peeples Valley and Antelope. He mapped and built many of the first roads in these areas. (Courtesy of Sharlot Hall Museum.)

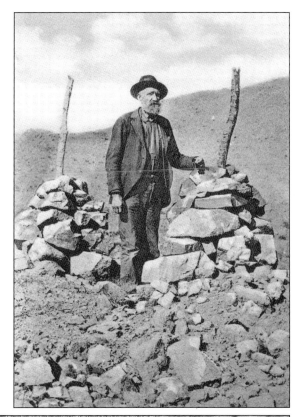

Charles Genung is buried in a family plot in Citizens Cemetery with some of his many children. Oddly, his devoted wife, Ida, is buried in a different cemetery.

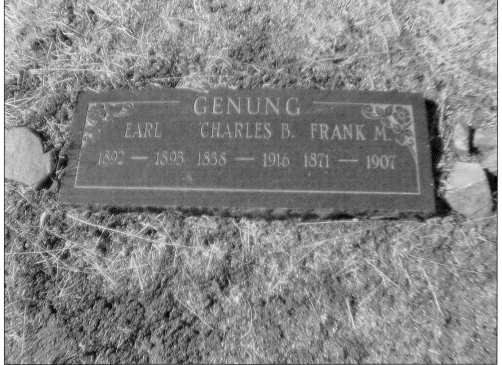

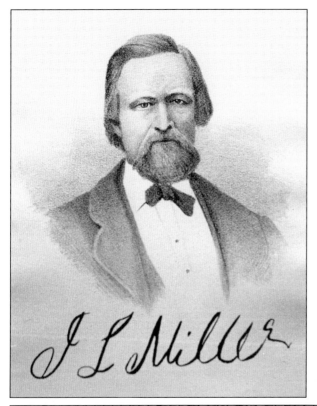

Jacob L. Miller arrived in the Arizona Territory in 1863, with his brother Samuel C. Miller, as members of the famed Joseph Walker party. The Miller brothers mined for gold along Lynx Creek, started a freight-hauling business after the town of Prescott was established, and homesteaded in the part of town that is now named for them, Miller Valley. (Courtesy of Sharlot Hall Museum.)

This is the modest gravesite of Jacob Miller, who died in Prescott in 1899. His brother Samuel is buried in the Pioneers' Home Cemetery.

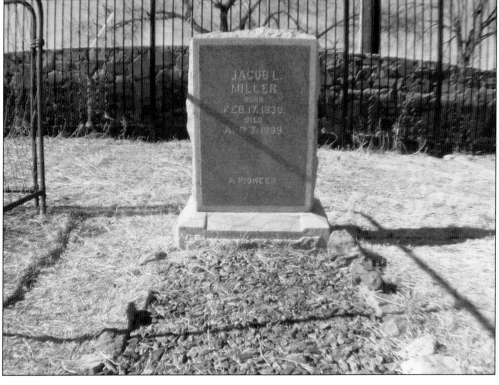

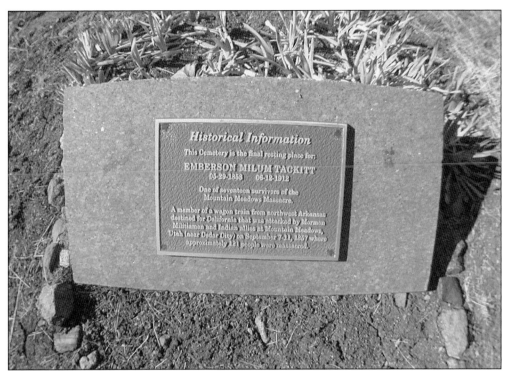

Much has been written about the 1857 massacre in Mountain Meadows, Utah, in which over 120 traveling migrant settlers were attacked and killed by members of the Church of Jesus Christ of Latter-Day Saints (the Mormons). There were only 17 survivors, one of whom, Emberson Tackitt, later settled in the Prescott area and is now buried in Citizens Cemetery.

The first Yavapai County lawman killed in the line of duty was Deputy John M. Murphy in 1885. He was shot to death by Dennis W. Dilda while trying to arrest Dilda on a theft charge. Dilda, later linked to other murders as well, was hanged for his crime and is buried in an unmarked grave elsewhere in Citizens Cemetery. This is a rare case of a killer and victim being buried in the same cemetery.

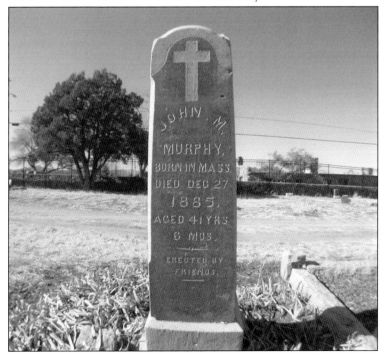

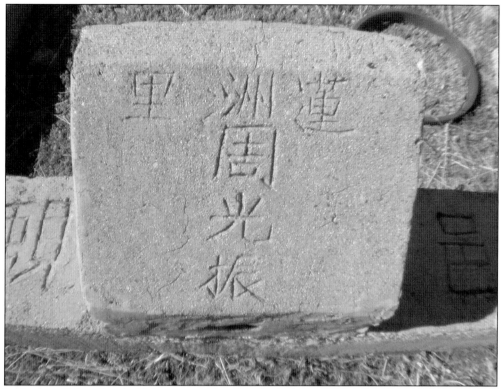

In the late 19th and early 20th centuries, Prescott had a large Chinese population that no longer exists. There is a small, segregated section of Chinese graves here, most unmarked with the exception of a few with surviving headstones.

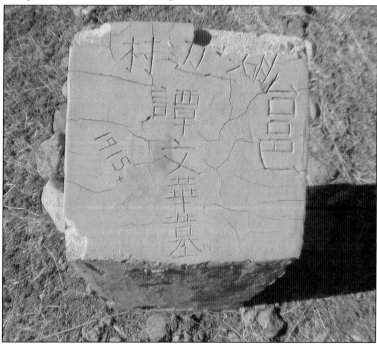

The number of remaining Chinese graves is relatively small because families often tried to raise funds to send their loved ones back to China and would then exhume them for this purpose. A few did not make it and remain interred in Citizens Cemetery.

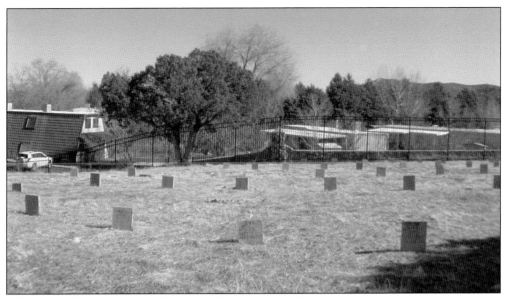

This section of the cemetery is known as the "Potter's Field," a place where people without families, the poor, and criminals and undesirables were buried in pauper's graves at county expense. Interestingly, these "undesirables" are buried facing west instead of the Christian tradition of east. Among those buried here is William Mingus, the miner for whom Mingus Mountain was named.

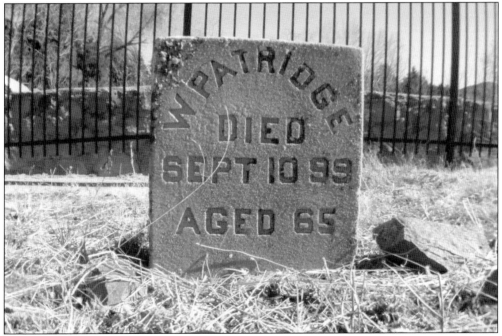

William Partridge (with name misspelled on his tombstone) shot and killed a stage stop proprietor named George H. "Yaqui" Wilson in 1877 down in the Antelope area of the county. He served time in Yuma Territorial Prison for the crime and was pardoned in 1880 by Territorial governor John Charles Fremont. Area folklore contends that Partridge was somehow tricked into killing Wilson by sinister businessman and miner Charles P. Stanton.

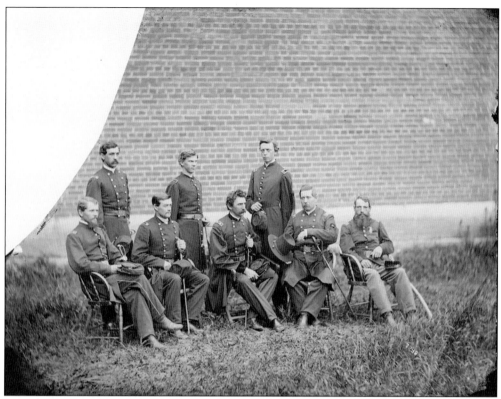

Lt. Col. William H.H. McCall, seated third from left in this photograph, was in the Union army during the Civil War. He later served on the staff of Gen. John H. Hartranft (seated center), which oversaw the prisoners in Washington, DC, who had been arrested and then hanged for conspiracy in the assassination of Pres. Abraham Lincoln. This photograph shows Hartranft's entire staff. (Courtesy of the Library of Congress Prints and Photographs Division, LC-B817-7758.)

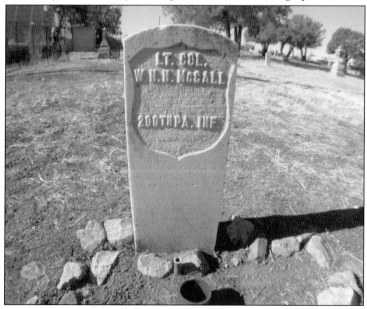

Lieutenant Colonel McCall later served at Fort Whipple in the Arizona Territory, located near Prescott. He also served as a deputy US marshal in Yavapai County. Upon his death in 1883, he was buried here in Citizens Cemetery.

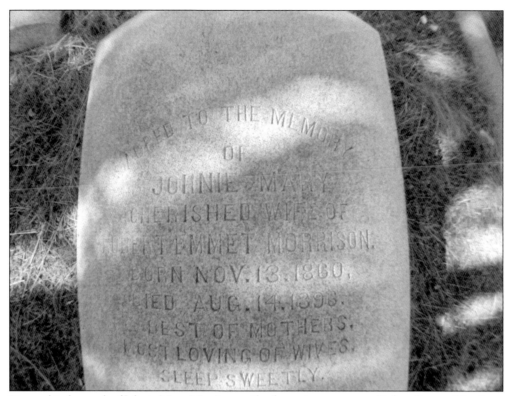

Pictured is the tomb of Johnie Mary Morrison, wife of prominent attorney Robert Emmet Morrison, who practiced law throughout the Arizona Territory and was active in Territorial politics. He is buried in a different cemetery, and the family still has descendants living in Yavapai County.

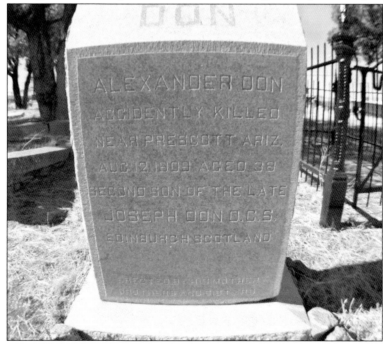

Unlike today, many tombstones of yore actually seemed to tell stories, leaving visitors to wonder what the details were. Alexander Don was "accidently killed near Prescott"

Citizens Cemetery is pictured here in 1963, overgrown with weeds, neglected, and encroached by development. Note the Best Western motel sign in the distance. (Courtesy of Sharlot Hall Museum.)

This is the cemetery around 1994, still overgrown with weeds and generally neglected. (Courtesy of Pat Atchison.)

It was in the state of decay above that John and Pat Atchison found Citizens Cemetery in 1994. They are pictured below at Citizens Cemetery in the 1990s. It was through their tireless efforts that the Yavapai Cemetery Association was formed and the cemetery once again became a beautiful resting place for the area's pioneer citizens. (Both photographs, courtesy of Pat Atchison.)

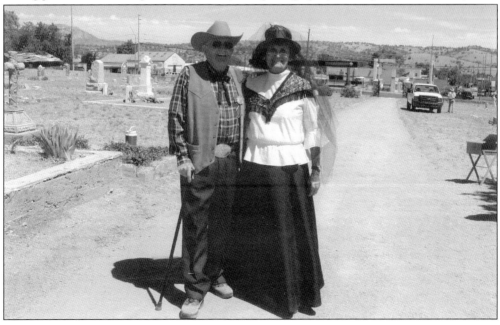

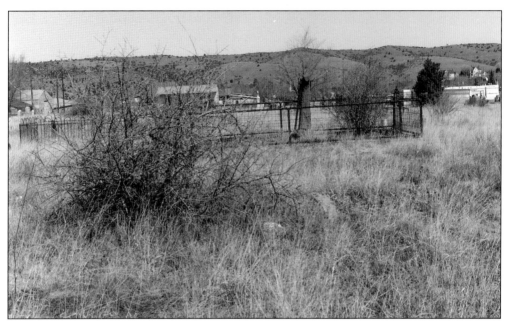

These 1994 photographs are a stark reminder of what can happen to cemeteries when they fall into neglect. The Atchisons had their work cut out for them. (Courtesy of Pat Atchison.)

Pictured again is Citizens Cemetery in 1994. Considering how many important men and women are buried here, it is remarkable that the cemetery suffered such neglect for so many years. (Courtesy of Pat Atchison.)

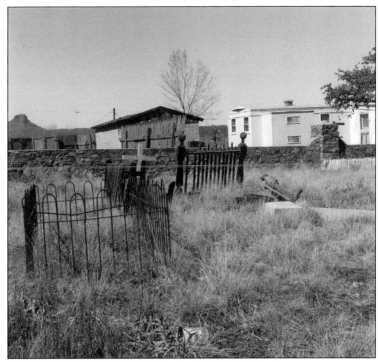

This is Citizens Cemetery as it exists today, well cared for and maintained by the Yavapai Cemetery Association.

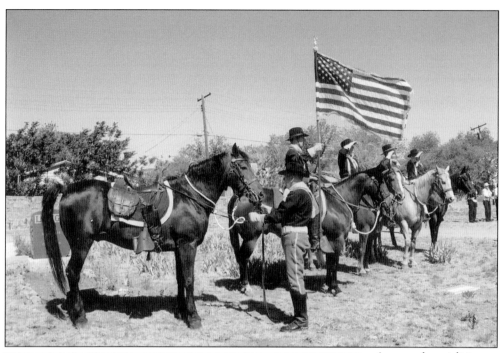

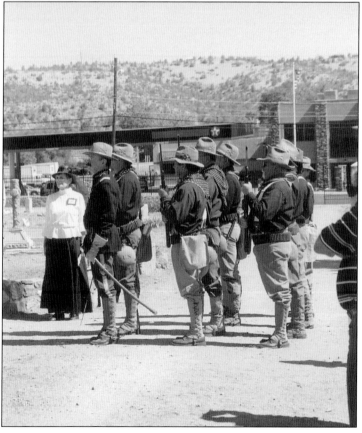

Among the traditions begun by Pat Atchison at Citizens Cemetery is a yearly Memorial Day observance in May, arranged in the style that such observances were held in the early 1900s. These photographs are from the 2007 observance, with Pat Atchison standing far left in the image below. (Courtesy of Pat Atchison.)

Two

Pioneers' Home Cemetery

The Arizona Pioneers' Home is a retirement and rest home in Prescott that is operated by the State of Arizona. It is one of only two state-operated nursing homes in America.

The home opened in 1911 on land donated by businessmen Frank M. Murphy and Thomas G. Norris. It is on a hill overlooking Prescott and can be seen from almost every section of the city. Originally, the home had a capacity of 40 men who were at least 60 years old and had been in the Arizona Territory for at least 25 years. A women's wing was opened in 1916. Today, the Arizona Pioneers' Home can hold 155 residents, and applicants must have lived in Arizona for 50 years.

In 1912, Dr. Warren E. Day donated a large plot of land off of Iron Springs Road to the Pioneers' Home for a cemetery in which residents of the home could be buried. This cemetery is directly adjacent to a smaller burial ground known as the Simmons Cemetery.

Many important Arizona pioneers are buried here. The cemetery remains in use and open to residents of the Pioneers' Home, although the rate of new burials has slowed due to the increasing popularity of cremation in recent years, as well as the newer trend of families shipping their loved ones back to family plots in other states.

The Arizona Pioneers' Home Cemetery is located on Iron Springs Road, a major thoroughfare in Prescott today.

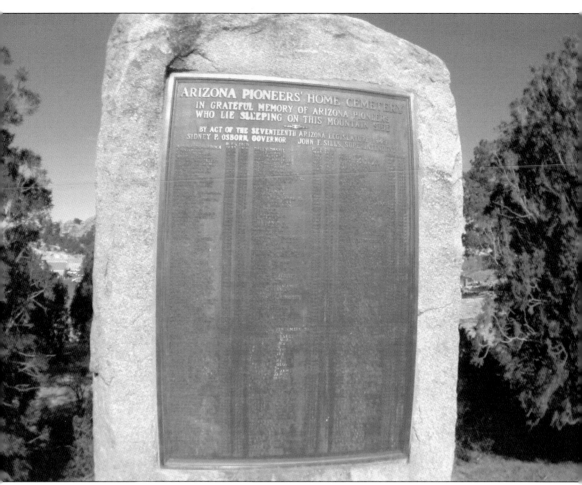

This monument, erected in 1945 "in grateful memory of Arizona pioneers who lie sleeping on this mountain side . . . by act of the Seventeenth Arizona Legislature," lists all burials in the Pioneers' Home Cemetery through 1938. It is a good information source for those researching the early day interments from the home.

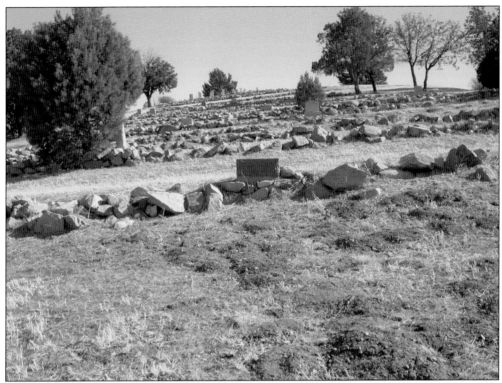

Because the cemetery is located on a hillside, parts of the grounds were layered and tiered to prevent erosion from rainfall. There are a number of unmarked graves in this section as well.

The top of the cemetery now overlooks a shopping center, which first opened in 1978 and was considerably remodeled in the mid-2000s.

Mary Katherine Horony (1850–1940), known by Western aficionados as "Big Nose Kate," was the common-law wife of legendary gunfighter and gambler Doc Holliday. She entered the Pioneers' Home in 1931. Like everything else connected to Doc Holliday and Wyatt Earp, this famous photograph of the Hungarian-born Kate has been the subject of debate and dispute. (Courtesy of Sharlot Hall Museum.)

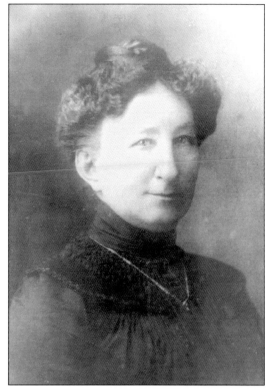

This is the grave of Big Nose Kate, or "Rowdy Kate," who later married a man named George Cummings. Wild West aficionados make pilgrimages to her burial site and leave coins, trinkets, and other items in tribute to her.

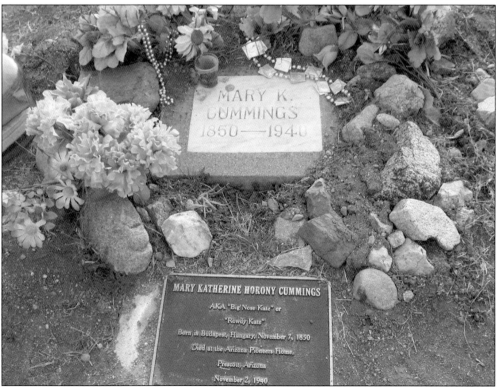

MARY K.
CUMMINGS
1850 —— 1940

MARY KATHERINE HORONY CUMMINGS

AKA "Big Nose Kate" or
"Rowdy Kate"
Born in Budapest, Hungary, November 7, 1850
Died at the Arizona Pioneers Home,
Prescott, Arizona
November 2, 1940

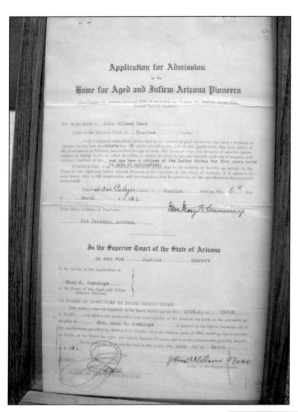

Seen here is the application form for the admittance of Mary Katherine Horony into the Pioneers' Home. She had initially been denied but was later admitted into the home after she took her case to her old friend Arizona governor George W.P. Hunt.

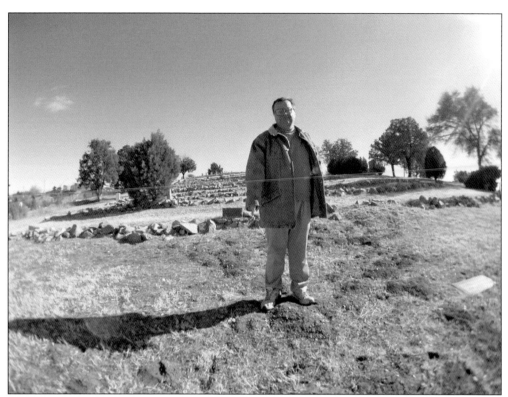

Historian Parker Anderson stands by the unmarked grave of John Miller, who died in 1937 and about whom very little is known. In 2005, a group of history revisionists exhumed him in an attempt to prove that Miller was actually the outlaw Billy the Kid, a claim that Miller had apparently once made.

This is the grave of Albert Behan (1872–1949), the son of notorious lawman John Behan. Albert's sister is buried in Citizens Cemetery. At one time, his stepmother had been Josephine Sarah Marcus Earp, the third wife of Wyatt Earp; she had previously been married to John Behan, Earp's enemy.

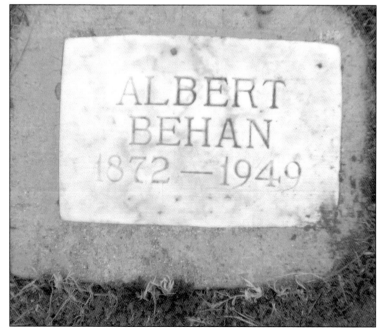

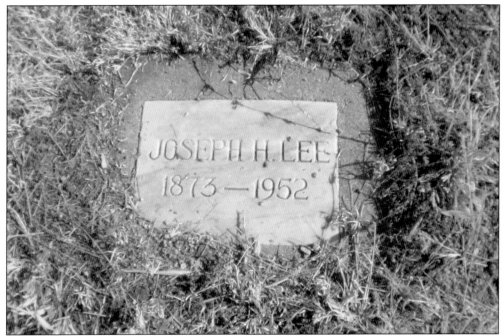

Joseph "Joe" Lee worked as an assistant to Indian trader Samuel S. Preston in Preston's trading post on the Navajo Indian reservation. There, in 1897, Lee and Preston helped capture the notorious Yavapai County outlaw Fleming Parker, who was later hanged for murder. At the time of his death in 1952, Lee was one of the last surviving participants in the famous Fleming Parker case.

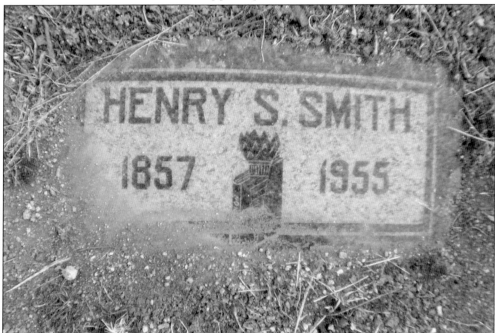

Henry Street Smith (1857–1955), a retired music teacher in Yavapai County, reportedly also claimed to be Billy the Kid. While Smith was far less known than John Miller, it is notable that there are two Billy the Kid pretenders in the same cemetery.

One of Yavapai County's most beloved figures is Sharlot Mabridth Hall, an acclaimed poet and historian who was the founder of the museum that bears her name. For a time, she held the official position of Territorial historian, making her the first woman to hold a salaried public office in Arizona. (Courtesy of Sharlot Hall Museum.)

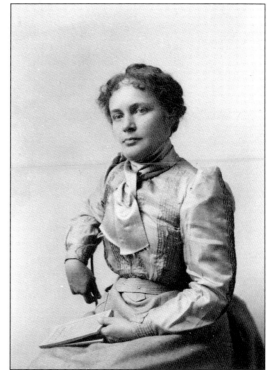

The casket of Sharlot M. Hall, seen here upon her death in 1943, sits inside the museum building she had constructed next to the first governor's mansion, which she had helped save in 1927. (Courtesy of Sharlot Hall Museum.)

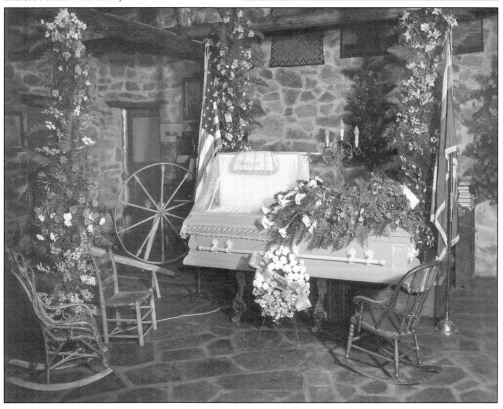

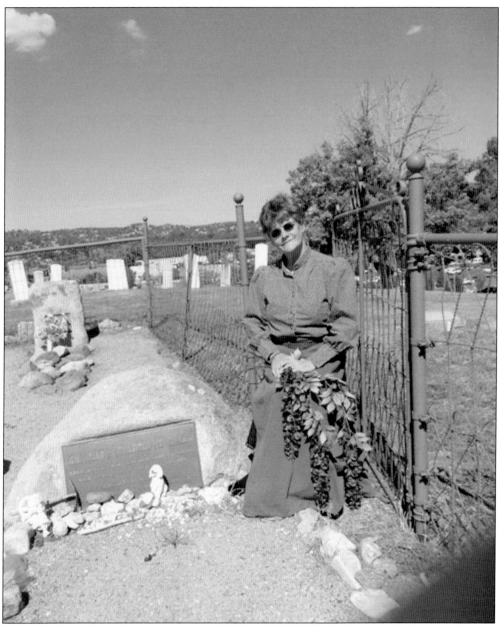

Local historian and Blue Rose Historical Theatre founder Jody Drake sits beside the grave of Sharlot Hall at the top of the hill in the Pioneers' Home Cemetery, located in a family plot with Hall's parents and other relatives. For many years, Drake has portrayed Sharlot Hall in one-woman Chautauqua performances around Arizona. (Courtesy of Randi Wise.)

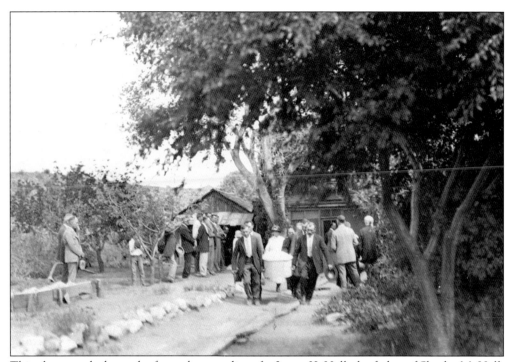

This photograph shows the funeral proceedings for James K. Hall, the father of Sharlot M. Hall, at his Orchard Ranch near Dewey, Arizona. Hall was a prominent and well-liked rancher in the area who reportedly had difficulty understanding his daughter's literary and preservation pursuits. (Courtesy of Sharlot Hall Museum.)

In the same family plot as Sharlot M. Hall are the graves of James Knox Hall and Adeline Boblett Hall, her father and mother, who immigrated to Arizona from Lincoln County, Kansas, in the late 1870s.

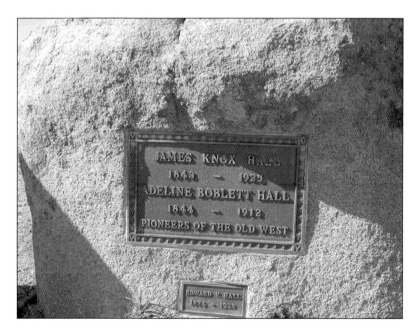

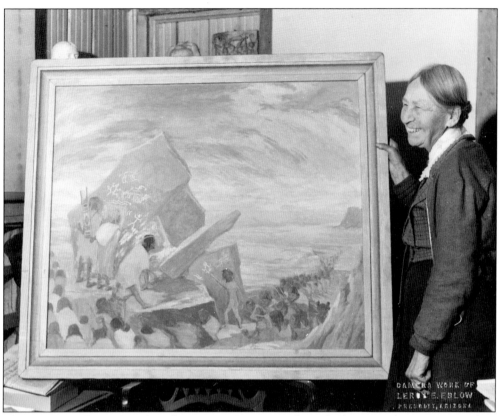

The paintings of Kate Cory have become an Arizona art legend. She painted many Hopi Indian landscapes and portraits, after having spent many years getting to know the Native American tribe and earning their trust. (Photograph by Leroy E. Eslow; courtesy of Sharlot Hall Museum.)

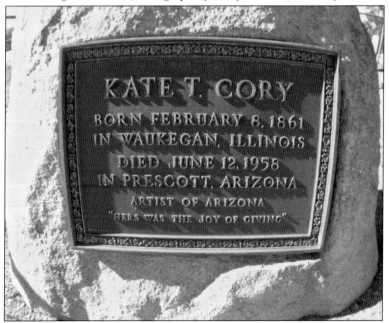

Kate T. Cory (1861–1958) is buried next to her longtime friend Sharlot M. Hall in the Hall family plot. "Hers was the joy of giving."

Albert F. Banta came to Arizona as a teamster with the first governor's party in 1864, which set up the first Territorial capital in Prescott. Banta was one of the few members of the party to remain in Arizona for the rest of his life. (Courtesy of Sharlot Hall Museum.)

Adjacent to the Pioneers' Home Cemetery is a tract called the Simmons Cemetery, which contains graves of local residents earlier than those from the Pioneers' Home. There is no fence that separates the two cemeteries.

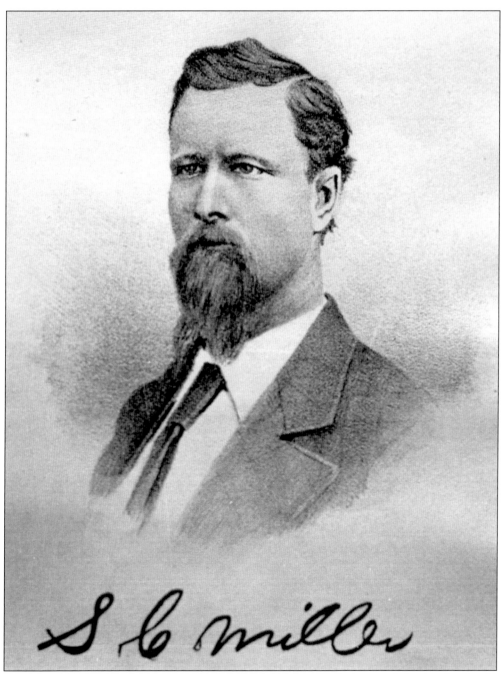

Samuel C. Miller came to Arizona with the Walker party in 1863 along with his brother Jacob. The two brothers stayed on and became prominent citizens in the new town of Prescott, settling and doing business in the section of town now named for them: Miller Valley. (Courtesy of Sharlot Hall Museum.)

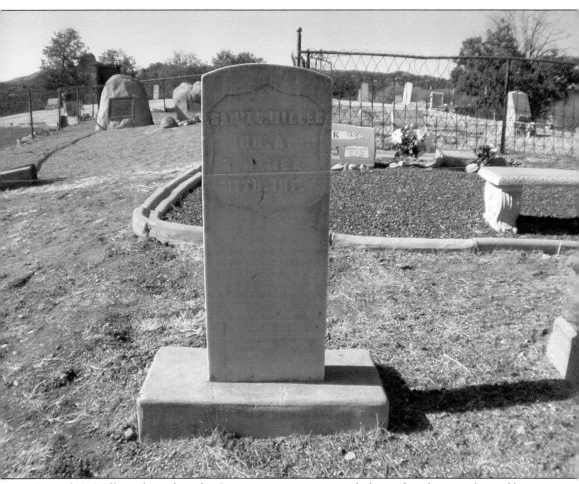

Samuel C. Miller is buried in the Simmons section, interred alongside other members of his family, including his children.

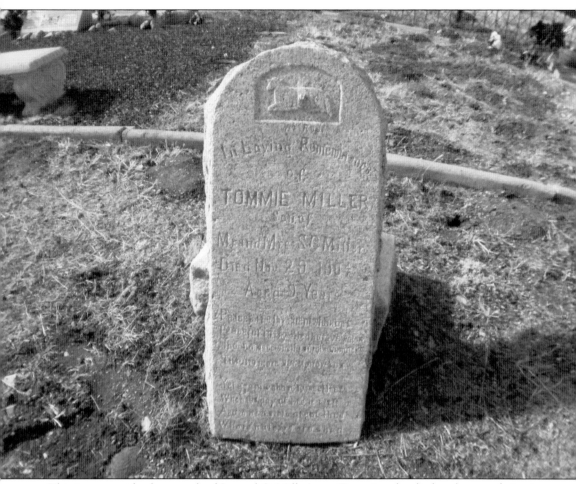

This is a graveside photograph of Samuel C. Miller's son Tommie, who died at the age of nine in 1904. During that era, many larger families had children who did not live to adulthood.

Three

JEROME "HOGBACK" CEMETERY

The town of Jerome was incorporated in 1876 on the steep side of Cleopatra Hill, situated on the north side of Mingus Mountain. For many years, it was a busy mining community, with rich copper and gold lodes. Mining kingpin William A. Clark held many mining interests here. At its peak, the town developed a reputation for lawlessness and vice among its inhabitants, though there were also many citizens who simply worked long hours for low wages in the mines.

The Jerome "Hogback" Cemetery gets its nickname from the shape of the hill it is located on. The Hogback hill is rocky, and rocks protrude from the ground throughout the cemetery. There was no organized planning, as this burial ground has its graves spread out in disorderly fashion.

After the mines started closing in the 1930s, Jerome became virtually a ghost town for several decades, until its bustling revival in the 1980s based on tourism. During the town's decline, the cemetery was neglected, and it became overgrown with brush. The tombstones fell victim to time, the elements, and vandalism. The last known burial here was Edward A. Lee in 1919.

With Jerome thriving once again today, Boy Scout troops and volunteers have worked on the upkeep of the Hogback, but the damage done in previous decades in still evident. Only 20 readable headstones remain, and there are large numbers of unmarked graves. Some descendants still care for certain graves here and regularly put flowers on them. Roger Every and the Jerome Historical Society have worked hard to document the burials here.

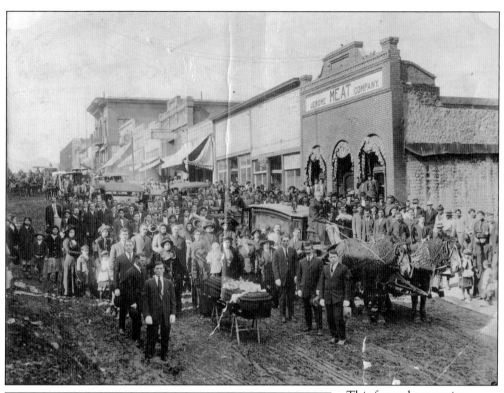

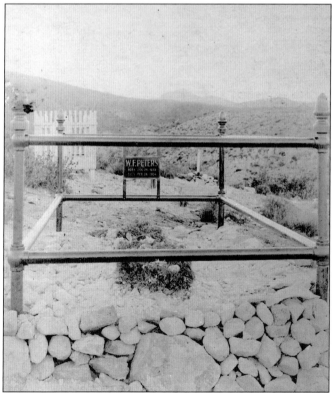

This funeral procession marching through the streets of Jerome is for a victim of the 1918 Spanish flu epidemic that decimated entire towns in the United States following World War I. The mourners are undoubtedly heading for the Hogback or the lower Jerome Pioneer Cemetery. (Courtesy of Jerome Historical Society 1995-61.)

This photograph of the tombstone of W.F. Peters was taken around 1904 and is the oldest known image of the Hogback Cemetery. The stone is no longer extant. (Courtesy of Jerome Historical Society 1995-100-3.)

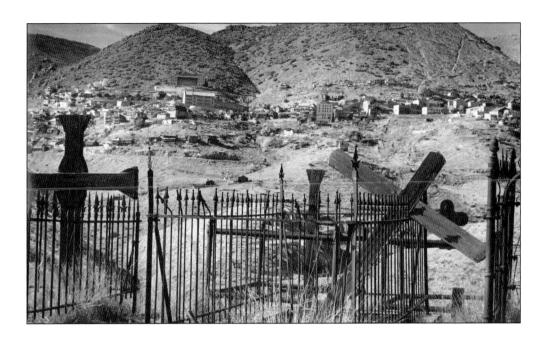

These two photographs of the Hogback Cemetery, taken around 1964, show the devastation that time had wrought on the burial ground. Jerome itself had a very small population at this time; it would be years before the town started to grow again and people would clean up the cemetery. (Above, courtesy of Jerome Historical Society Clark 76.1; below, courtesy of Jerome Historical Society HVY-20-1-a.)

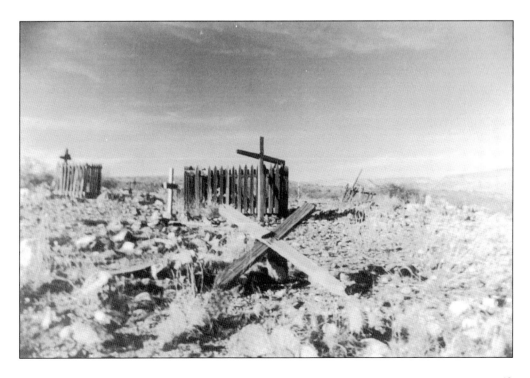

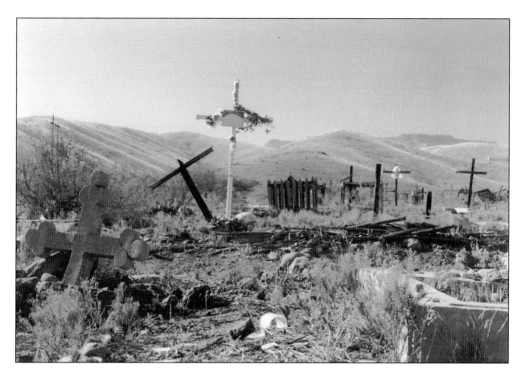

These photographs, also from around 1964, further show the damage from neglect and the elements over the years, before caring people started to work the grounds again. (Above, courtesy of Jerome Historical Society HVY-20-3; below, courtesy of Jerome Historical Society HVY-20-4.)

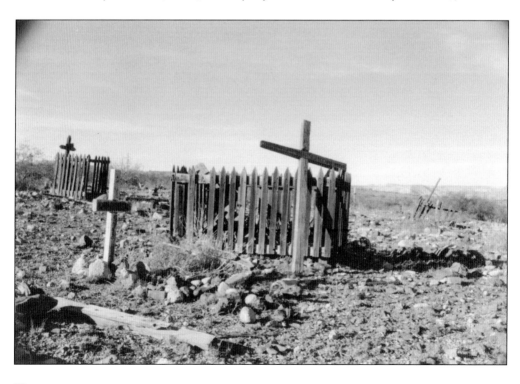

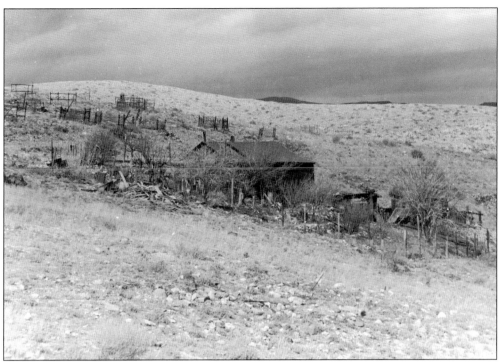

This c. 1972 photograph shows the ruins of a house near the boundary of the Hogback Cemetery. This house is no longer standing. (Courtesy of Jerome Historical Society J-90-459-156.)

This is the entrance to the Jerome Hogback Cemetery as it looks today, showing the shape of the hill that spawned its name. Parker Anderson is seen in the distance.

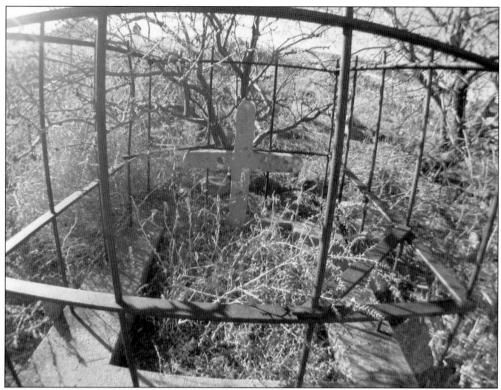

Many of the men who worked in the mines of Arizona died and were buried far away from the homes where they once lived. It is likely that some of their families back home were never even informed of their deaths.

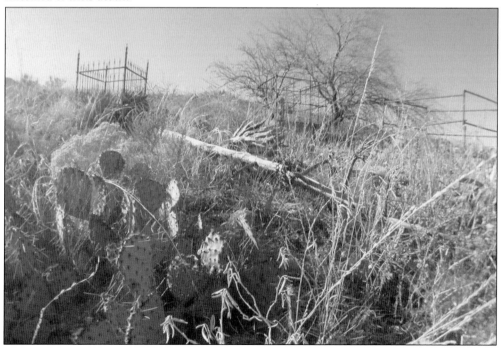

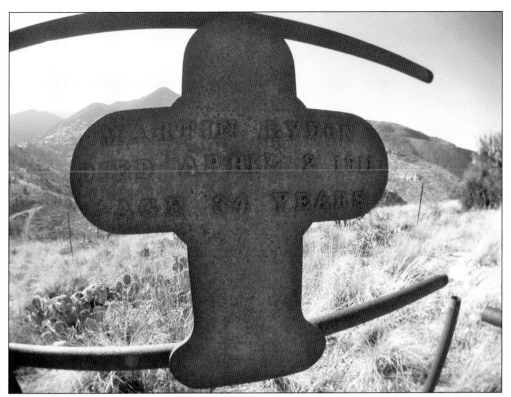

A number of ironwork markers and fences exist in this cemetery, often imported from Eastern foundries. This one commemorates "Martin Lydon / Died April 2, 1911 / Age 34 Years."

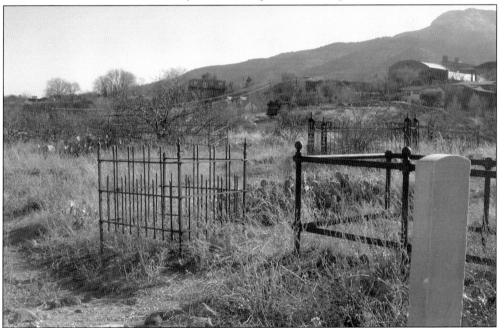

This is an overview of the Hogback seen from a different perspective. Why the cemetery was situated on this type of hill is not known.

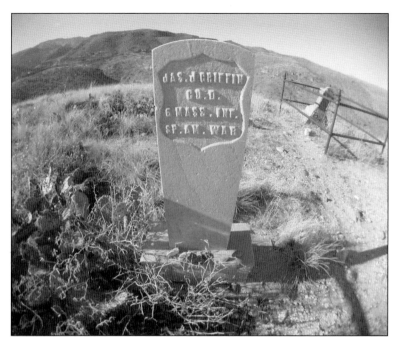

Jason J. Griffin, who served in the Spanish-American War in 1898, is the only known military veteran buried in the Hogback. There may be others, as many of the graves are of unidentified individuals whose names are lost to history.

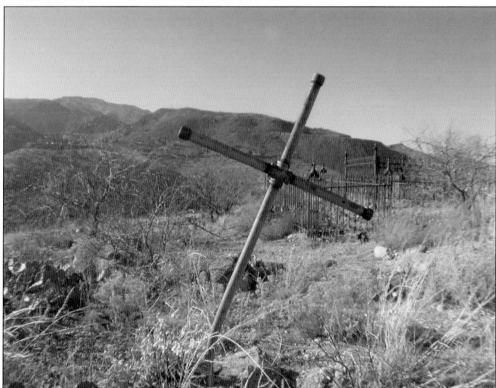

The miners in Jerome were poor and made do with what materials were at hand. Those who could not afford ornate crosses for the graves of their loved ones improvised with whatever they had, such as these pipes. This sincerity and devotion to the Lord eclipses far more elaborate religious shrines.

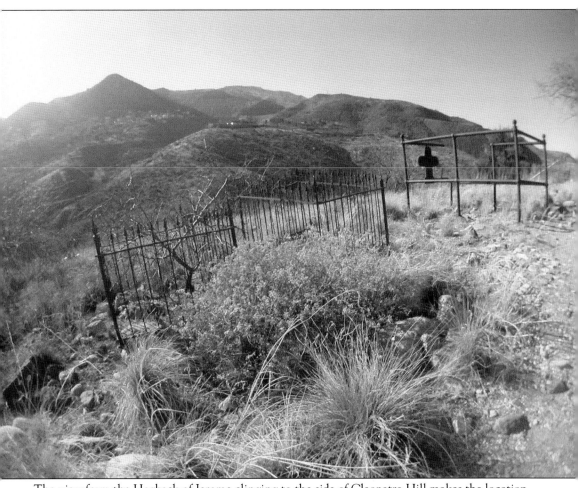

The view from the Hogback of Jerome clinging to the side of Cleopatra Hill makes the location a prime destination for photographers.

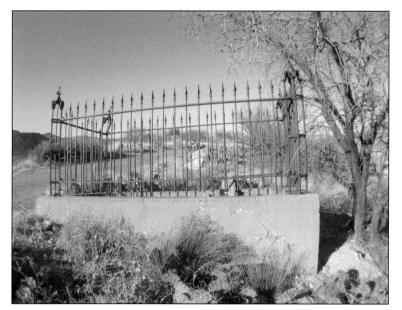

Iron fences were sometimes put around gravesites by family members who could afford them, usually as a protection against digging coyotes.

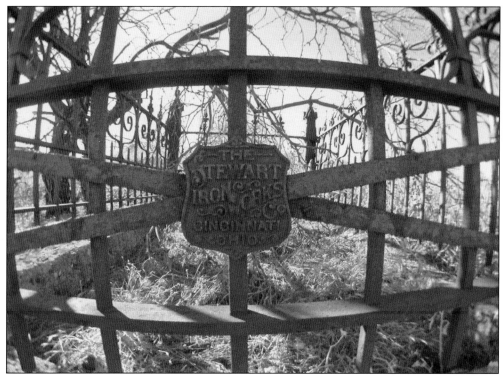

This ironwork fence actually has the name of the foundry, The Stewart Iron Works Co. of Cincinnati, Ohio, emblazoned upon it. Foundries produced the metal castings used to memorialize and mark gravesites, preventing plant erosion and other environmental factors responsible for destroying gravestones over time. There were not many foundries in the Southwest to have the work done locally, as most were based in New England.

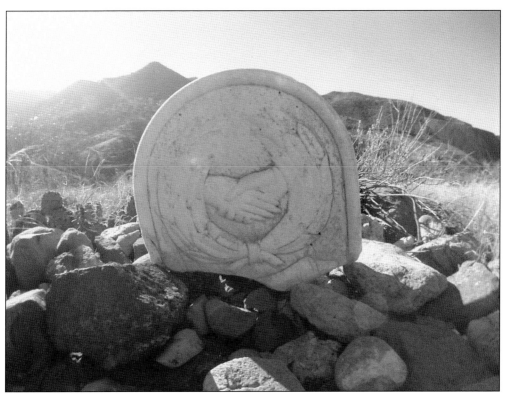

The ravages of time can be seen on the graves of the men and women who rest here.

Today, the Jerome "Hogback" Cemetery is cared for by volunteers, but even they cannot repair the damage that the edifice of time has wrought. The cemetery is a very significant site for an important historic town.

Four

JEROME PIONEER CEMETERY

In 1915, the Jerome Town Council purchased 40 acres of land from the US Department of the Interior to establish a new cemetery, as the Hogback Cemetery was nearly full. This burial ground was located farther down the mountain from Jerome, on flatland closer to Clarkdale.

As with the Hogback, many of those interred are Mexican, owing to the mining companies' penchant for employing Latino workers because they could pay them less than white men. After the mines closed and Jerome very nearly became a ghost town, burials virtually ended at the Jerome Pioneer Cemetery.

The last official burial here was in 1939, although four unauthorized burials are believed to have occurred since then, with the most recent in 1981. Over the years, the cemetery was ravaged by neglect and vandals. According to the Jerome Historical Society, only about 200 of the approximately 700 graves here have been identified.

Today, while attempts have been made to clean up the cemetery by concerned citizens and Boy Scout troops, it still shows the ravages of time. Fortunately, vandalism has tapered off some by the recent encroachment of housing development near the cemetery.

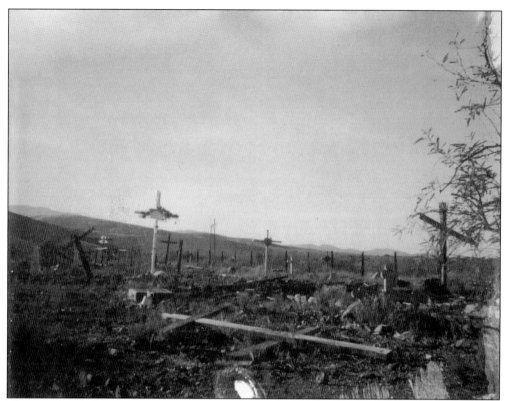

These undated photographs are probably from the 1960s and show the decay and neglect that befell the Jerome Pioneer Cemetery after the mines had closed. Indeed, for a while, the town itself had not fared much better. (Above, courtesy of Jerome Historical Society HVY-20-8; below, courtesy of Jerome Historical Society HVY-20-10.)

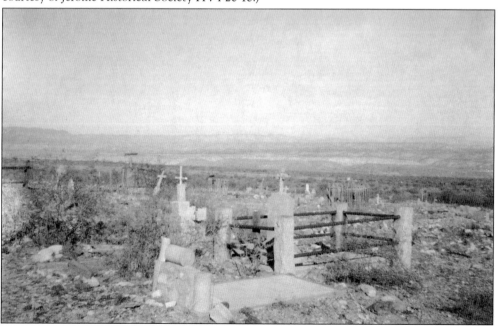

Today, efforts have been made to clean up the cemetery, but it remains overgrown with brush and encroached by development.

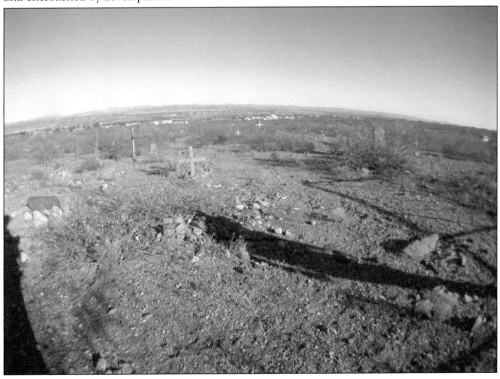

This is the sign to the Jerome Pioneer Cemetery as it appears today. It was crafted by hand, but the craftsman is still unidentified. No one officially has charge of the cemetery.

Some graves in both of Jerome's cemeteries are still cared for individually by relatives of those interred.

Unfortunately, like many cemeteries across the nation whose graves show the ravages of time, as the ones pictured here, the natural deterioration of markers and tombstones is seen across all regions and climates of the country.

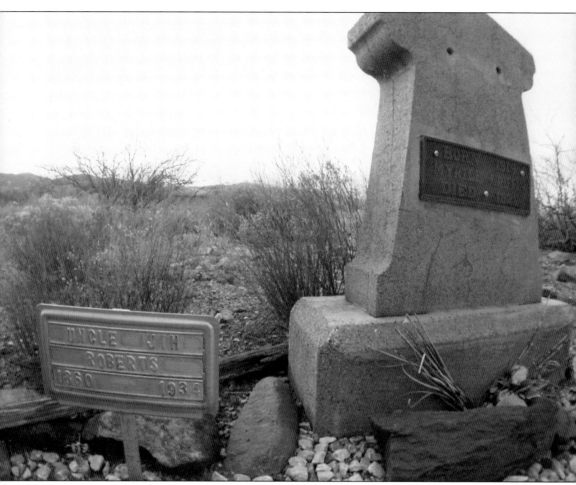

One of the disputed burial sites of famed Jerome/Clarkdale lawman "Uncle" Jim Roberts, who died in 1934. Most historians believe he is buried in Valley View Cemetery in Clarkdale, but a marker for him is also located here in the Jerome Pioneer Cemetery, in a plot with a child named Myrtle Griffin who died of hookworm in 1922. There is no known connection between Roberts and the child.

Five

CLARKDALE VALLEY VIEW CEMETERY

The town of Clarkdale was originally formed to house the miners and other employees of William A. Clark's United Verde Copper Company. The town was constructed down the mountain from Jerome, near the mine's smelters.

After the mines closed in the 1930s, Clarkdale, like Jerome, struggled for survival and ultimately succeeded. Today, it is a scenic, historical, and pleasant town.

The Clarkdale Valley View Cemetery started with resident burials but began to take Jerome's burials after the Jerome Pioneer Cemetery fell into disuse and disrepair. Valley View is fairly unique in that it does not conform to the tradition of graves facing east. In fact, in different sections, the graves face a number of different directions.

Valley View has separate sections for Freemasons as well as for members of the Elks Lodge BPOE. It is an old cemetery, but remains in active use today.

The cemetery is divided into multiple sections and is quite large, with older and newer graves.

The older section has seen decay from the ravages of time, much like other cemeteries in the area.

The Elks Lodge BPOE has several sections for its members, mostly from the Jerome Lodge (actually located in Clarkdale today). They allow only flat tombstones in their sections.

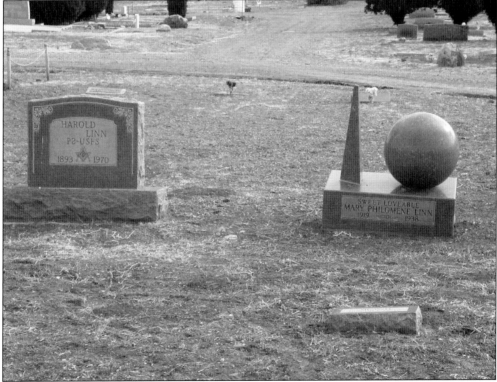

Adjacent to the marker for Harold Linn (1893–1970), this highly unusual sculpture honoring "Sweet Loveable" Mary Philomen Linn (1919–1938) is possibly of Masonic origin, as the secretive fraternal order of Freemasons commonly erected symbols and monuments to impart conjecture and debate among nonmembers.

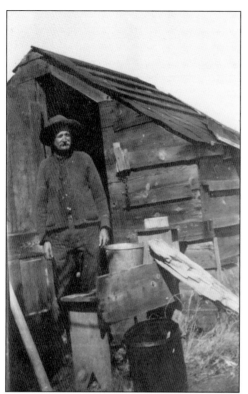

The famous Jerome/Clarkdale lawman, "Uncle" Jim Roberts, is seen here in his old age. Stories are still told about him in the area, most notably about his shooting of a fleeing Clarkdale bank robber in 1928. Uncle Jim passed away in 1934. (Courtesy of Sedona Historical Society.)

The burial place of Jim Roberts is in dispute. Most historians believe (corroborated by his death certificate) that he is buried here with his wife under this stone that bears no additional names or dates. But, as seen in chapter four, a marker for him exists in the Jerome Pioneer Cemetery as well.

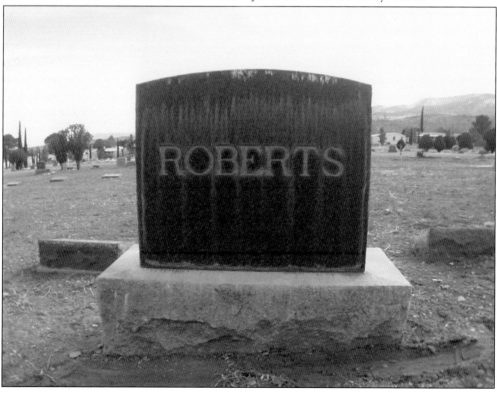

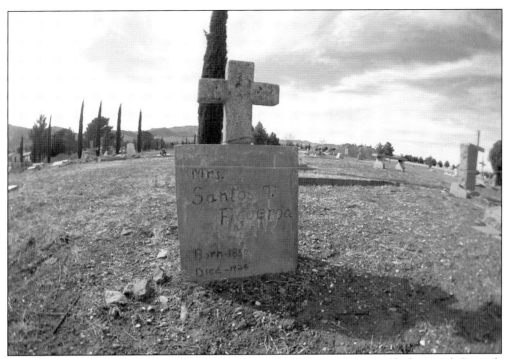

Unlike the Jerome cemeteries, Valley View was racially segregated in its early days, with Spanish sections for the area's Mexican residents. Here lie Mrs. Santos T. Figueroa (1850–1926) and Geronimo Calderon (1850–1937).

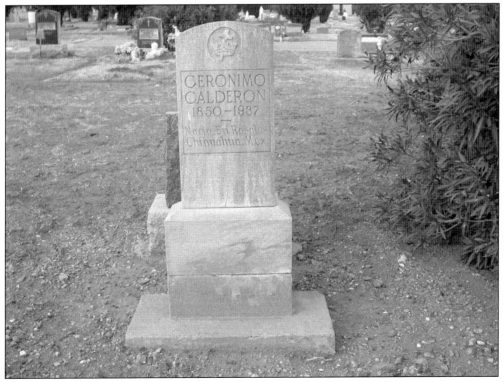

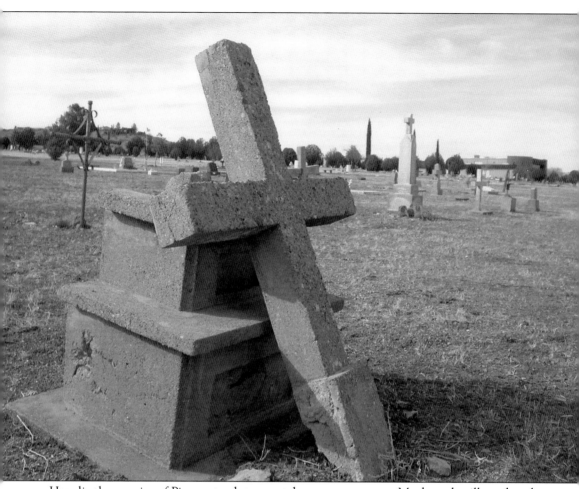

Here lie the remains of Pioneer tombstones and grave monuments. Much work still needs to be done to restore the grounds to their original state.

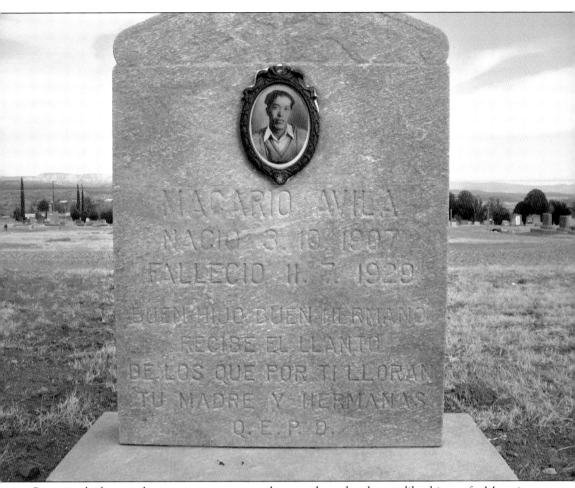

Surprisingly, few people opt to put permanent photographs on headstones like this one for Macario Avila (1907–1929), but it does make for a beautiful memorial.

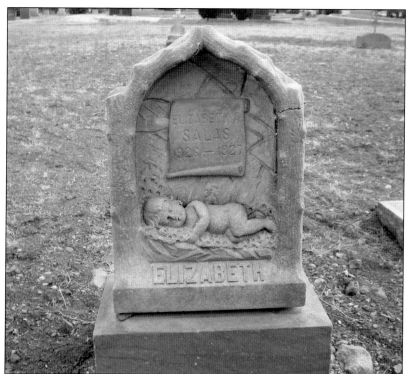

Pictured is the touching grave of Elizabeth A. Salas (1926–1927), a stark reminder of the high mortality rate of children in bygone eras.

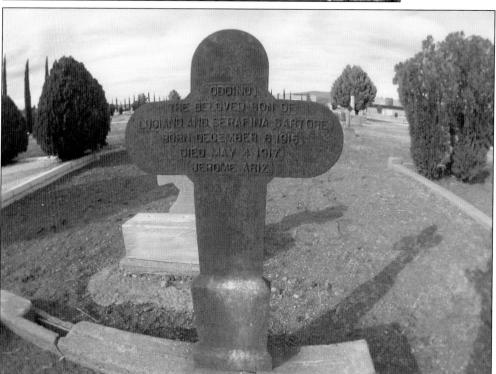

The gravesite of Oddino Sartore (1915–1917) boasts a cast-iron marker of Mexican origin, probably imported for this particular grave.

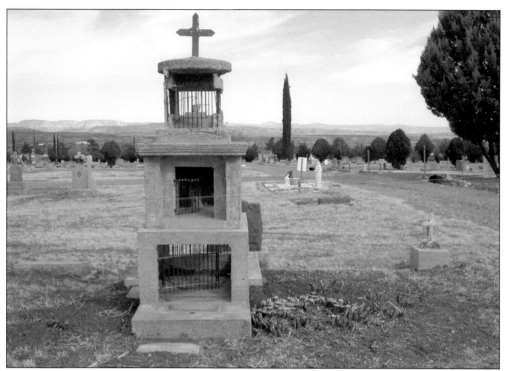

This unusual marker almost resembles a giant cage. Inside, there are broken remnants of small Catholic statues.

One of the statues inside this marker is visibly worn and broken away from time.

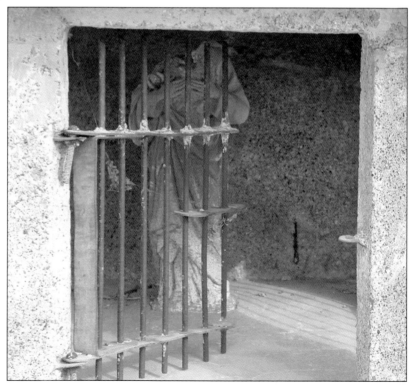

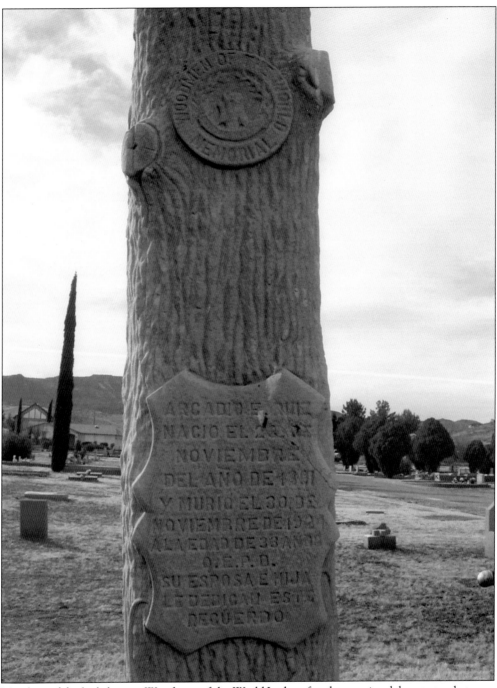

Members of the little known Woodmen of the World Lodge often have quite elaborate tombstones, like this one memorializing Arcadio E. Ruiz.

Six

SKULL VALLEY CEMETERY

Skull Valley is a rural ranching community located 12 miles West of Prescott. It is one of the most beautiful sections of Yavapai County. It is unknown how it received its rather macabre name, which has been the subject of considerable speculation over the years.

Today, the population of Skull Valley is around 525 people. A small museum operates there, displaying the area's rich ranching history.

The Skull Valley Cemetery is located a short distance outside of town on the main road between Skull Valley and Prescott. Among those interred here are the famous Western artist and sculptor George Phippen and his family, who lived in Skull Valley.

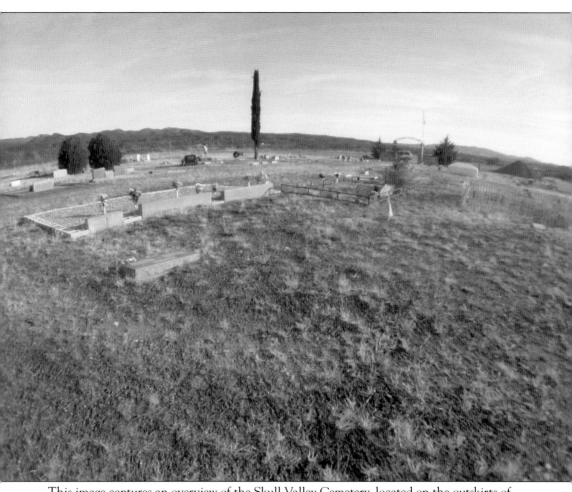

This image captures an overview of the Skull Valley Cemetery, located on the outskirts of town in a pleasant glade.

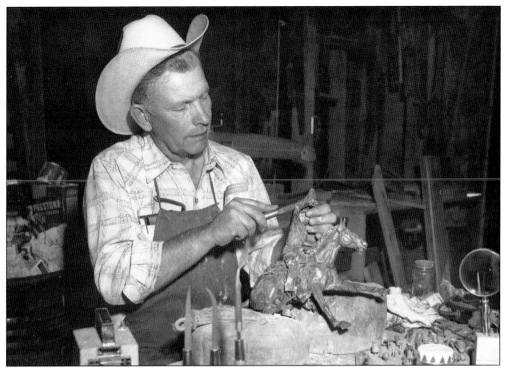

The famed painter and bronze sculptor George Phippen lived in Skull Valley and had his studio there. This c. 1960 photograph shows him at work on a small bronze image. (Courtesy of Sharlot Hall Museum.)

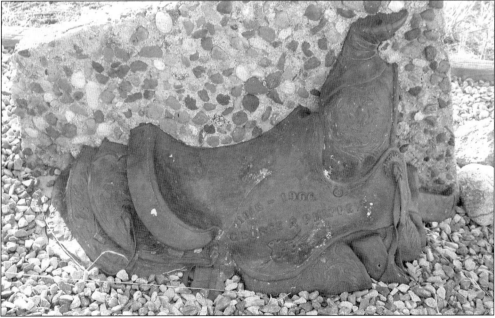

The grave of George Phippen (1915–1966) features a uniquely sculptured saddle on his tombstone, designed especially for him. Personal relics were often incorporated on the tombstone to honor the life of the deceased.

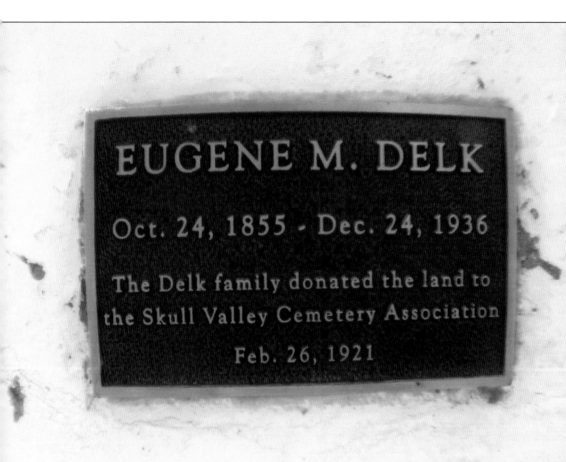

The burial place of Eugene Delk (1855–1936), who donated the land for the Skull Valley Cemetery, is pictured here. This plaque is on a solid wall that encloses his grave.

Seven

CONGRESS PIONEER CEMETERY

In the southern desert section of Yavapai County, gold was discovered in 1884 by Dennis May in what is now Congress (once originally known as Martinez), not far from Rich Hill, where the richest gold strike in Arizona history occurred in the 1860s. Soon, the area was inundated with miners and mining companies, and by 1893, the Santa Fe Railroad established a stop at a nearby area named Congress Junction.

After the mines closed in the 1930s, the town of Congress became deserted, but Congress Junction managed to hang on, and soon it became known as just Congress. Congress has survived and has a bustling population today.

The first Congress Cemetery (at one time known as Martinez Cemetery) was located in the desert not far from the mines, and most of those interred were undoubtedly miners and their families. Burials ended here in the 1910s, with the notable exception of famed Idaho miner Ben Caswell. After the 1910s, Congress burials occurred in a new cemetery not far away (discussed in chapter eight).

For many years, the Congress Pioneer Cemetery was neglected and fraught with vandals. Today, it is lovingly taken care of by Congress residents, although only a few headstones remain. It is one of the most striking, picturesque cemeteries in Yavapai County.

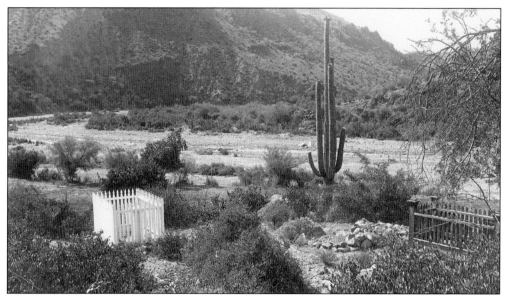

The Congress Pioneer Cemetery is pictured here in 1903. It was still in use at this time. (Courtesy of Sharlot Hall Museum.)

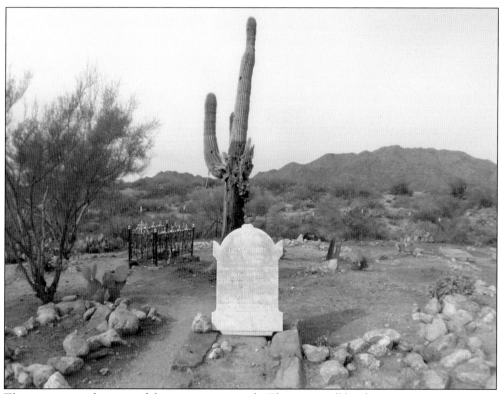

This is a present-day view of the cemetery grounds. That may well be the same saguaro cactus as seen in the above 1903 photograph. In the foreground is the tombstone of Joseph Vietti.

This is the entrance to the cemetery today. As evidenced here, it is well cared for by local residents.

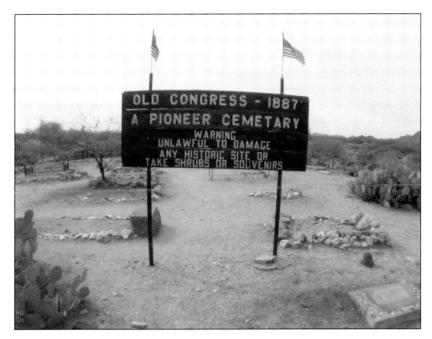

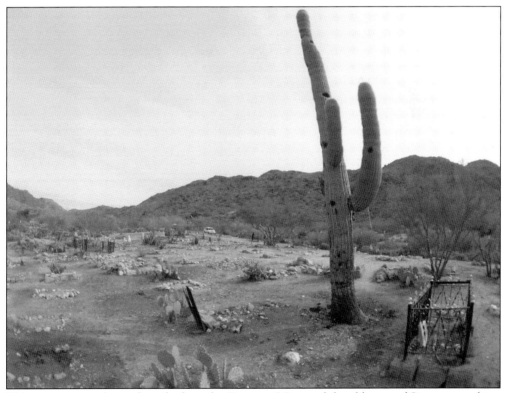

This cemetery was located not far from the Congress Mine and the old town of Congress, making it convenient for residents and miners to bury their dead.

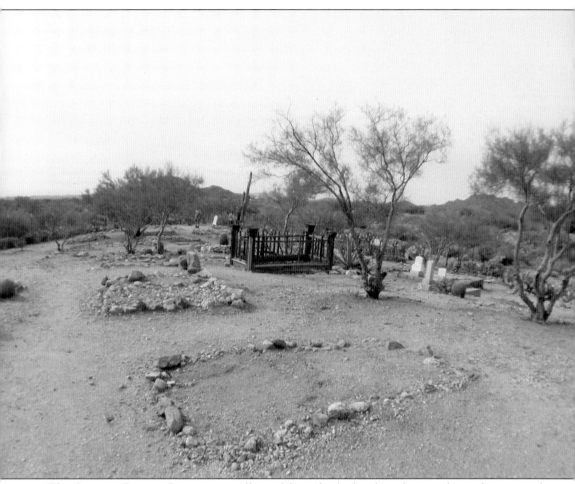

The Congress Pioneer Cemetery is well cared for today by local residents and is perhaps one of the most beautiful and atmospheric of its kind in the Southwest.

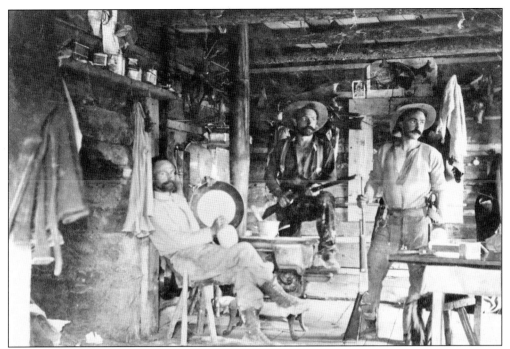

The famed Idaho miners Lew [spelled "Lou" in the marker below], Ben, and Dan Caswell are seen here in their Idaho cabin near the Thunder Mountain gold claim in the early 1900s. The Thunder Mountain discovery by the Caswell brothers in 1894 caused a major gold rush in Idaho at the time. (Courtesy of Idaho State Historical Society #73-57-18.)

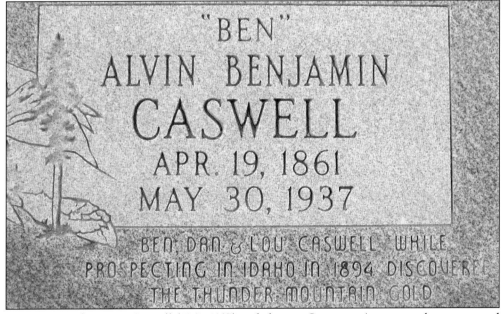

It is a mystery how Ben Caswell (1861–1937) ended up in Congress, Arizona, in later years and an even bigger mystery as to why he was buried in the Pioneer Cemetery (which was no longer in use at the time of his 1937 death) instead of the newer Congress Cemetery. His final resting place is this lonely desert grave, located far from his Idaho home.

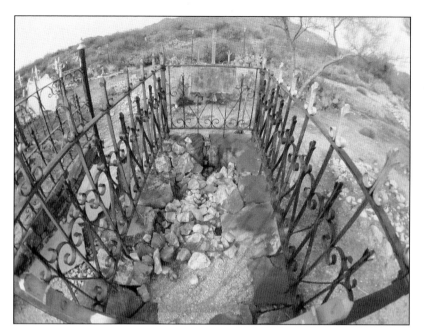

Some very old graves tend to sink with age, especially in a desert climate.

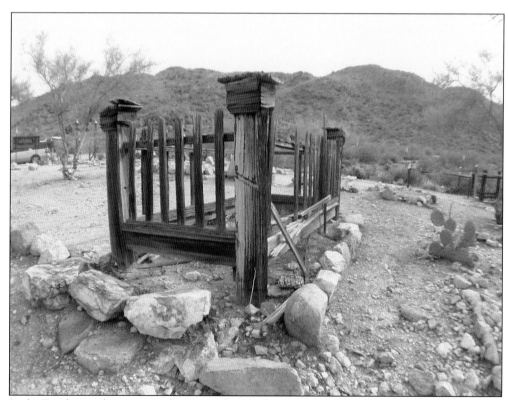

In the Southwest, fences were often erected around gravesites to keep coyotes and other predators from digging at them.

Only a small handful of graves, like this one of an infant named Eloicita Mouelthrop, still have markers in the Congress Pioneer Cemetery.

Once again, old cemeteries from this era contain the graves of many children, demonstrating the high mortality rate of the young in those rough eras.

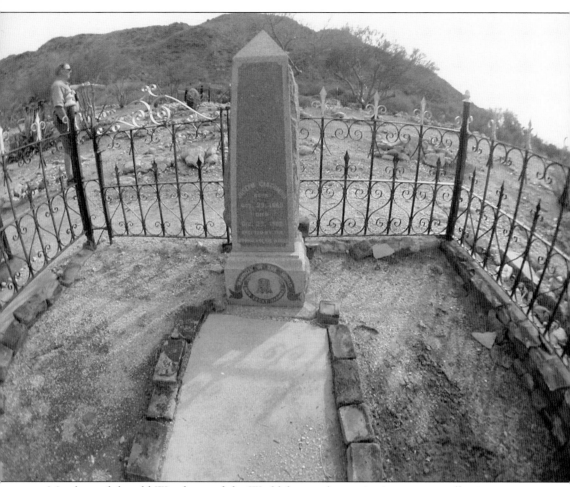

Members of the old Woodmen of the World fraternal organization were usually given ornate tombstones, often shaped like trees or, as in this case, engraved with images of trees, to symbolize the deceased's membership in the lodge.

Eight

CONGRESS CEMETERY

When the Congress Pioneer Cemetery ceased to be used in the 1910s, a new burial ground was established not far away. Like the first graveyard, this one was also in distant view of the mines.

The main Congress Cemetery is still in use today, with burials from the town's current inhabitants. The town of Congress has experienced a significant population increase in recent years, with retirees discovering its scenic desert beauty and comfortable climate.

Both cemeteries in Congress are located on gravel roads nestled at the base of the Martinez Mountains near the mines. Far in the distance, but very visible from the cemetery and all points in Congress, is the famous Vulture Peak skyline in neighboring Maricopa County.

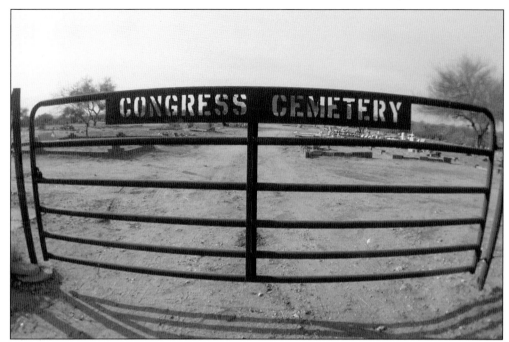

This is the entrance to the main Congress Cemetery, not far away from the old Congress Mine and the Pioneer Cemetery.

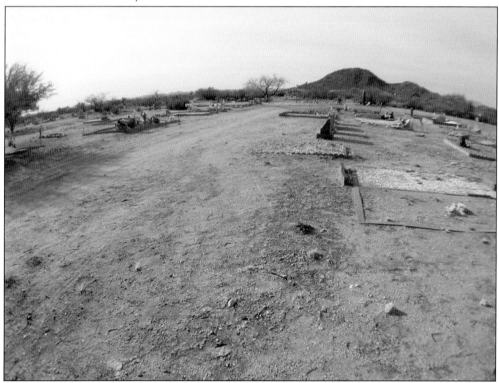

Most of the older graves are located on the east end of the cemetery, whereas newer burials took place on the west side.

There are several Spanish crypts in this cemetery, again reflecting how common it was for mining companies of bygone eras to hire large numbers of Mexicans.

Desert cemeteries seem to have a quiet beauty and serenity all their own. People occasionally seek them out as places of meditation.

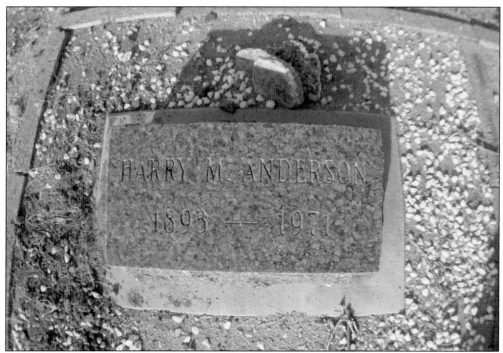

Pictured are the headstone and footstone for Harry M. Anderson (1893–1971), a World War I veteran who served as mayor of Hillsboro, North Dakota, from 1937 to 1941. He was also chairman of the Traill County (North Dakota) Republican Party during the 1960 elections. He later retired to Congress, Arizona, with a new wife and began a new family.

In pioneer days, children had a much higher mortality rate than today, and many older cemeteries have many children and babies interred within them.

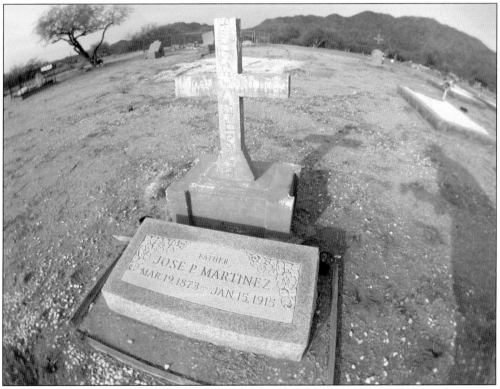

Little is known about the life of Jose P. Martinez (1973–1915), "father." As a section of Congress seems to have once been called Martinez, it is possible that this man was a member of the family it was named for.

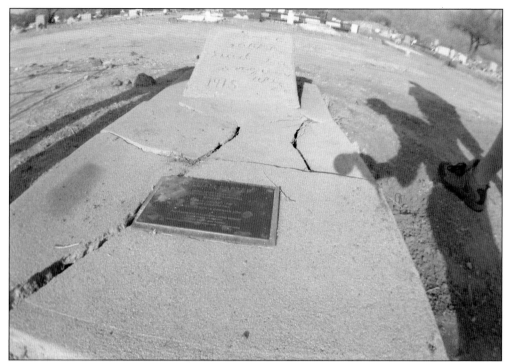

Seen here are lasting reminders of times gone by in the older section of this cemetery. At this time, there has been no historical study of the graves in the Congress burial grounds. The plaque above memorializes William Carter, who was born in England and died in Congress, Arizona. Below is the marker for Juan Valencia, who died in 1923.

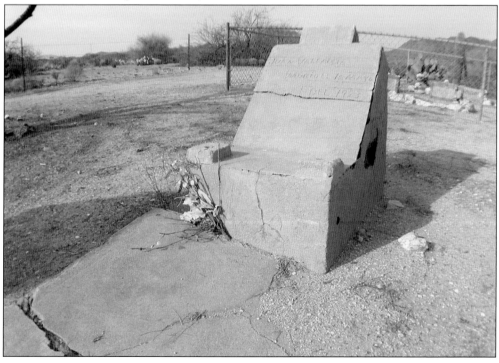

Nine

ISOLATED BURIAL SPOTS

There are often places where graves are not necessarily in cemeteries. In bygone eras, it was often acceptable to bury loved ones on one's own property if desired. Sometimes people who died on migrating wagon trains were buried on the spot and left. There are many reasons for isolated burial spots.

This chapter focuses on a small number in Yavapai County, some well known, others not. There are probably many more for which no visible trace has survived.

In later years, laws have been enacted that severely restrict the ability of families to bury people anywhere outside of a cemetery; so in essence, these lonely graves seem to represent, for better or worse depending on your point of view, a time of greater freedom in America. In some cases, family members or devoted taphophiles still care for these isolated burial spots today, and some are better cared for than larger cemeteries.

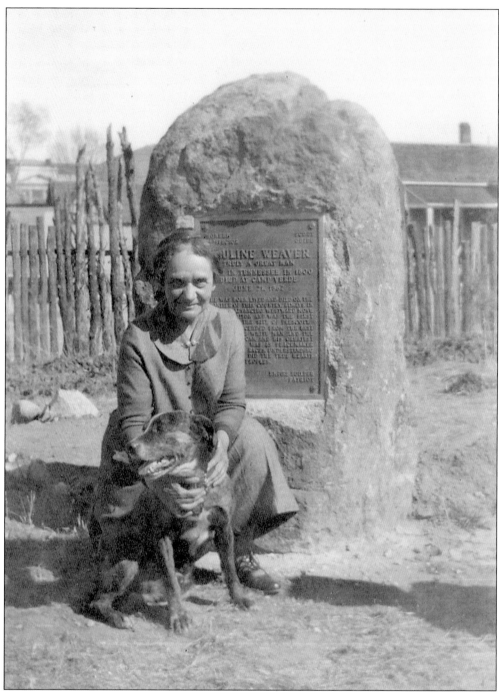

Mountain man and Army scout Pauline Weaver, for whom many Arizona geographical landmarks are named, was initially buried in a San Francisco military cemetery upon his death in 1867. But in 1929, Arizona historians, including Sharlot M. Hall, led efforts to have him exhumed and reburied next to the old governor's mansion in Prescott, which had become a museum started by Hall, who is pictured here next to Weaver's new tombstone and monument. (Courtesy of Sharlot Hall Museum.)

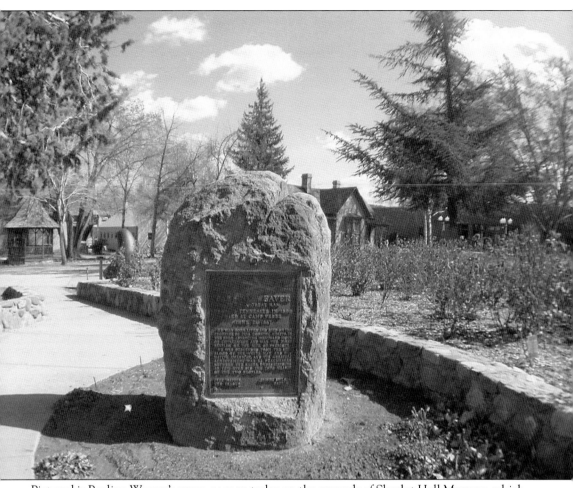

Pictured is Pauline Weaver's grave, as seen today on the grounds of Sharlot Hall Museum, which has grown considerably since Hall's death.

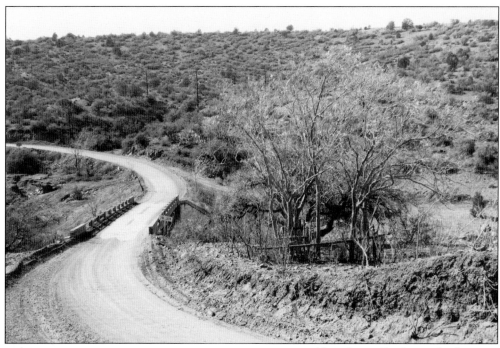

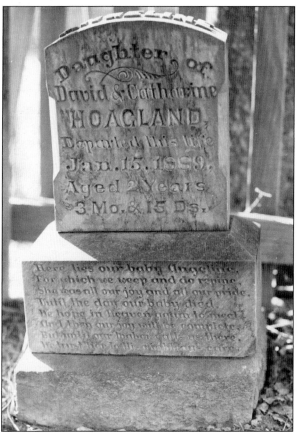

Along Lynx Creek, not far from Prescott, lies the isolated grave of Angeline Hoagland, who died in 1889 at the age of two near her parents' house. These two photographs show the gravesite in the 1960s. Angeline's mother and sister are buried in Citizens Cemetery. "Here lies our baby Angeline / For which we weep and do repine / She was all our joy and all our pride / Until the day our baby died / We hope in Heaven again to meet / And then our joy will be complete / But until our maker calls us there / We trust her to His righteous care." (Both photographs, courtesy of Sharlot Hall Museum.)

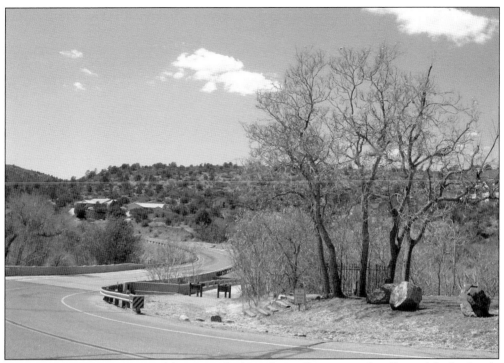

Angeline's gravesite is pictured here as it looks today, still extant and well cared for by family members. It is now encroached by development.

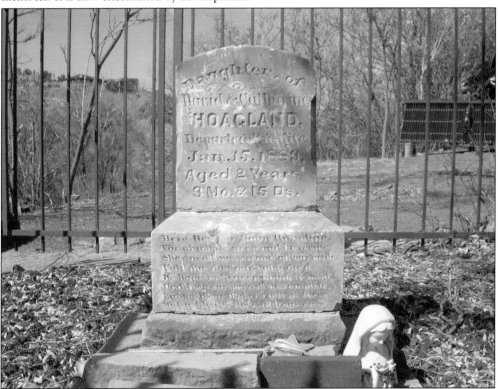

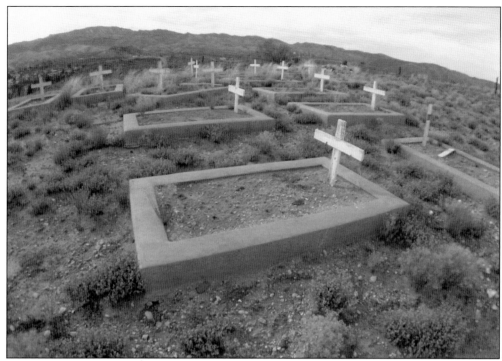

On a hill overlooking Clarkdale is a very small graveyard belonging to the Yavapai-Apache Indian tribe. The crosses could indicate that these were tribe members who converted to Christianity. There are no named headstones.

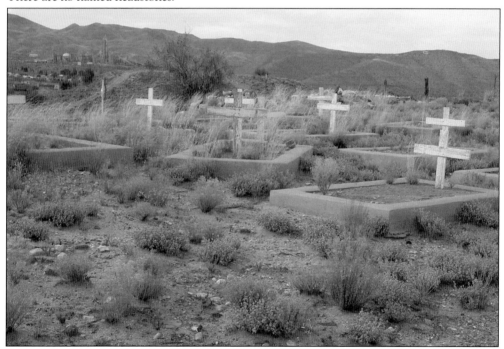

Seen here is yet another view of the Yavapai-Apache tribal cemetery in Clarkdale. Photographs of Native American burial grounds are rare. Note the Clarkdale Cement Plant in the background.

Ten

GHOST TOWNS

The state of Arizona is filled with ghost towns, ruins of once-bustling towns that simply no longer exist. Many of these were mining communities, and the towns vanished when the mines dried up.

Yavapai County has quite a few ghost towns, and this chapter focuses on a handful of their cemeteries. After the towns ceased to exist, most of their cemeteries fell into total decay and neglect, and in a few cases, evidence of them disappeared altogether.

Happily, some civic groups, Boy Scout troops, and other organizations have tried to clean up and restore many ghost town cemeteries in recent times. The Arizona Pioneer Cemetery Research Project (APCRP), headed by Neal Du Shane, has done extensive work in documenting burials in such graveyards.

Ghost town ruins and cemeteries are usually in remote locations, often inaccessible to normal vehicles, so visitors must use caution.

OCTAVE CEMETERY

● RESTORED BY LUCILLE KELLEY ●
PHOENIX /X/'S SCOTTSDALE /X/ SCOUTERS
● HIGH COUNTRY / WHEELERS.

Little remains of the once-prosperous mining town of Octave in the Antelope region of southern Yavapai County, with the exception of a few building foundations and a cemetery. Boy Scouts and other concerned researchers care for the site.

The cemetery has no named headstones on any of its graves, although some of those interred have been identified through official records, burial records, newspaper obituaries, and even dowsing. Groups such as the Arizona Pioneer Cemetery Research Project (APCRP) have done much work at sites such as these.

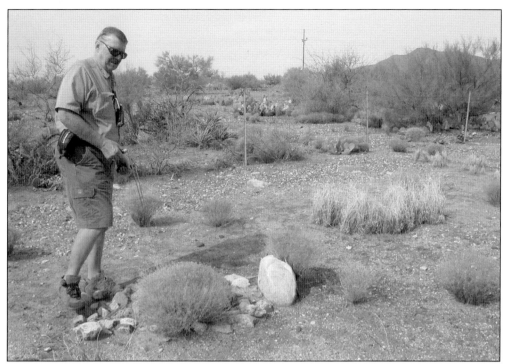

This grave has been identified by the APCRP as the burial place of George M. "Yaqui" Wilson, a stage stop owner who was murdered by William Partridge in 1875. Above is Neal Du Shane, who made the identification on behalf of the APCRP.

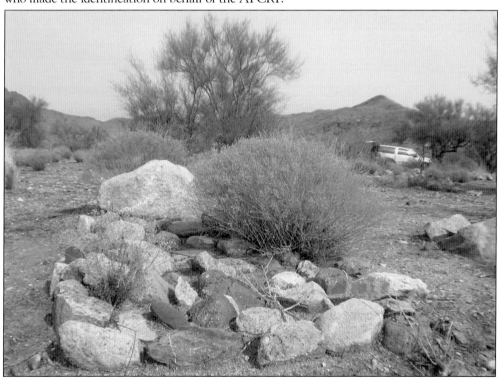

Homemade metal crosses mark some of the graves in this cemetery.

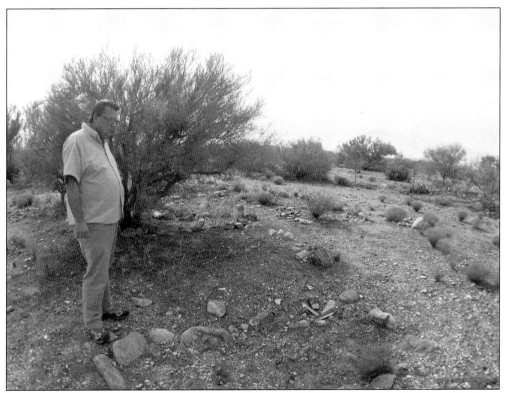

Parker Anderson stands by the grave identified by the APCRP as the burial place of Froilana Lucero, who committed suicide in 1900. Years earlier, in 1886, her brothers are believed to have murdered the notorious miner and businessman Charles P. Stanton, in retaliation for Stanton's unwanted affections toward her.

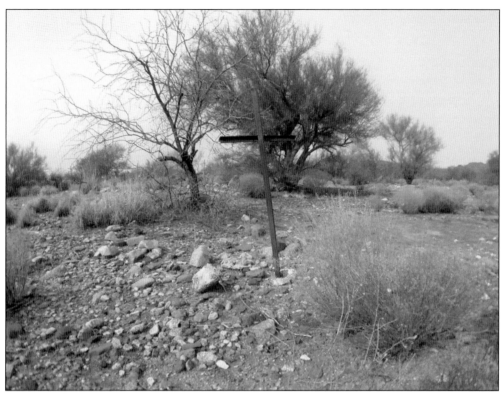

Visiting sites like this can be a profound experience, as one realizes that most of those buried here are completely forgotten, yet once, they were here on Earth, the same as we are.

As with many ghost towns, everyone left once the mining ended, except for the dead.

The ghost town of Weaver, named for legendary pioneer Pauline Weaver, lies not far from Octave and today consists only of ruins and a cemetery. These two photographs show the Weaver Cemetery in 1948, which was already a while after the town was abandoned. Below is the marker for Adolfo Olea, who only lived for six months in 1901. (Both photographs, courtesy of Sharlot Hall Museum.)

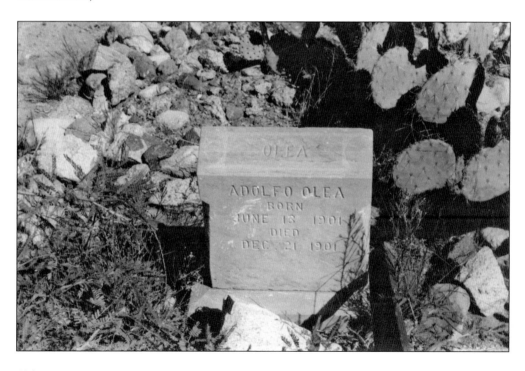

Here are two more images of the Weaver Cemetery from 1948. These photographs are historically invaluable, as none of the tombstones and fences seen here are still in existence. (Courtesy of Sharlot Hall Museum.)

This photograph of the cemetery was taken in 1964 by Vera Hangartner, who had moved to the nearby area with her family and often explored the desert with her daughter Darla Anderson. The image shows the Weaver Cemetery overgrown in weeds and brush. (Courtesy of Parker Anderson.)

This image also was captured in 1964 by Vera Hangartner. Both of these photographs still show some original markers that are no longer extant at the cemetery. (Courtesy of Parker Anderson.)

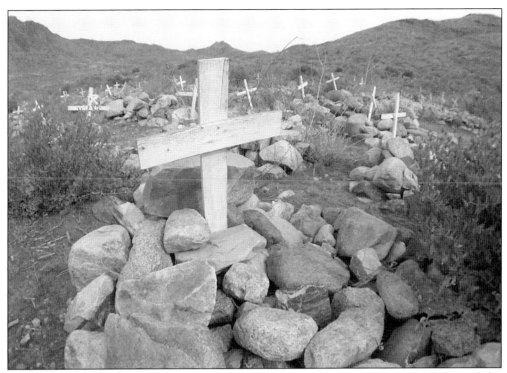

Today, each of the graves bears a white cross, placed there by Scout troops who help tend the site. No named headstones remain.

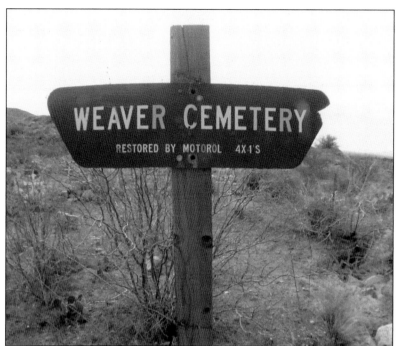

As with Octave, virtually nothing remains of the town of Weaver except for some building foundations and the cemetery, cared for by groups such as the APCRP.

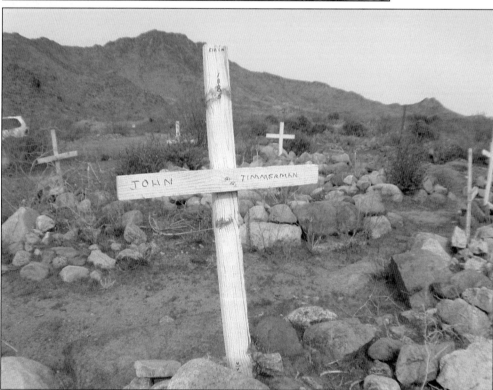

Neal Du Shane of the APCRP has identified this grave as being that of John Timmerman, who was murdered in 1877 in an unsolved crime. Area folklore contends that the murder was masterminded by Charles P. Stanton.

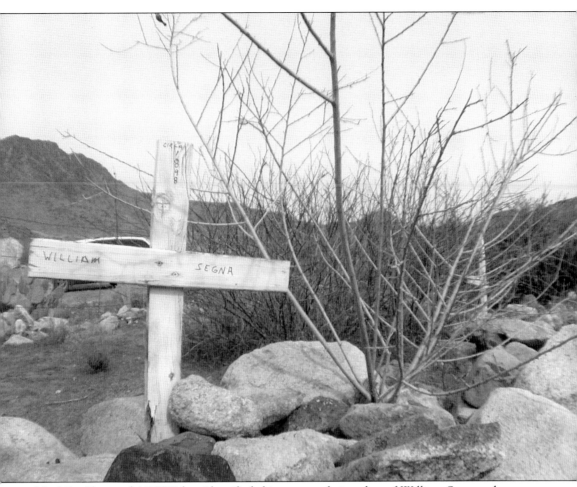

Neal Du Shane of APCRP has identified this grave as being that of William Segna, who was murdered by Vincente Lucero in 1898. This crime caused the *Arizona Journal Miner* newspaper call for the town of Weaver, which had become known for much lawlessness, to be wiped off the map.

Most visitors to these ghost town cemeteries are usually tourists, taphophiles, and occasional individual miners who still work small independent claims in the region.

The current fence around the Weaver Cemetery was apparently built by a civic club in 1983.

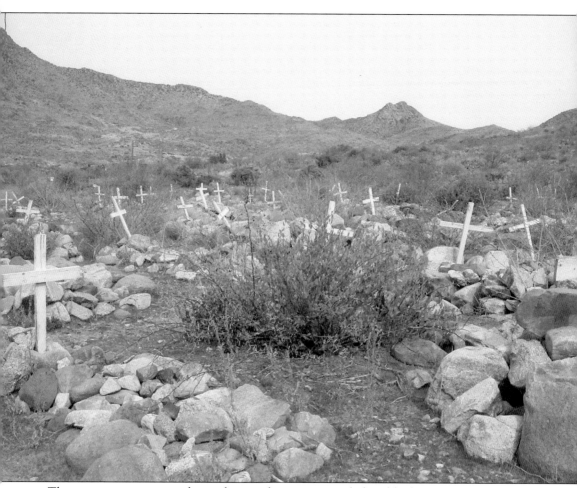

The mountains, quite unchanged since this area was inhabited by busy mining towns, still overlook and guard the area.

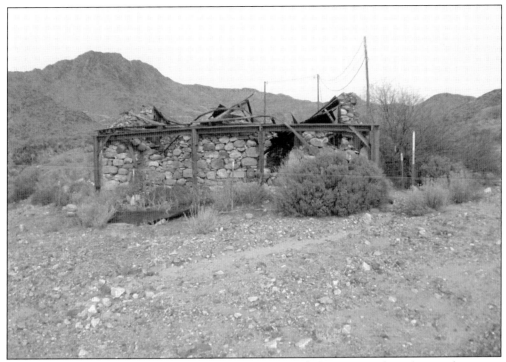

These photographs of the ruins of the Weaver Stagecoach Stop were taken almost adjacent to the cemetery.

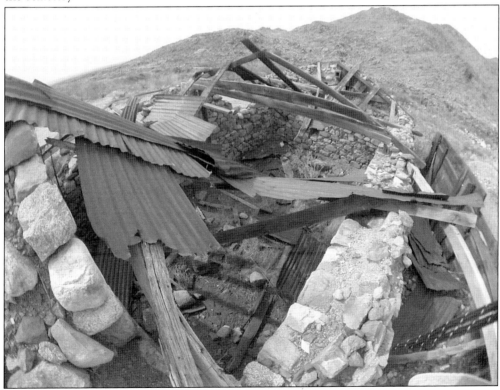

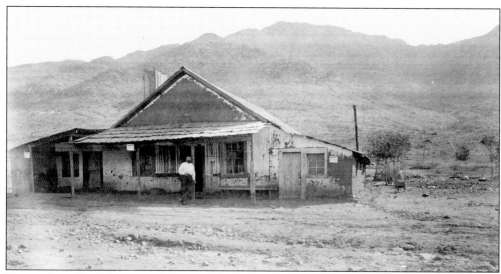

This is the only authenticated photograph of Charles P. Stanton, standing in front of his store in the town that bore his name. The town of Stanton, located near Weaver and Octave, once consisted of several hundred people, mostly miners on the legendary Rich Hill, which overlooked the town. Charles P. Stanton has a villainous reputation and was considered the town boss. (Courtesy of Sharlot Hall Museum.)

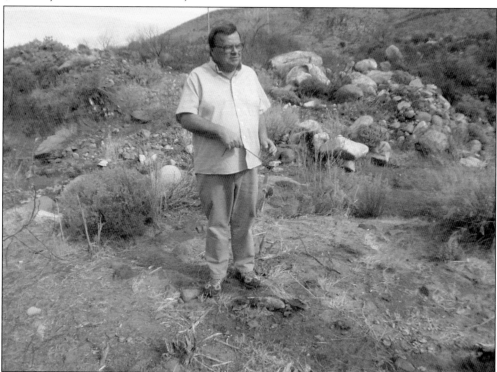

Records show that the town of Stanton had a cemetery, but all physical traces of it have been vanquished by time. However, the APCRP believes they have discovered it along Antelope Creek. In this photograph, Parker Anderson stands by the spot believed to be the grave of Charles P. Stanton.

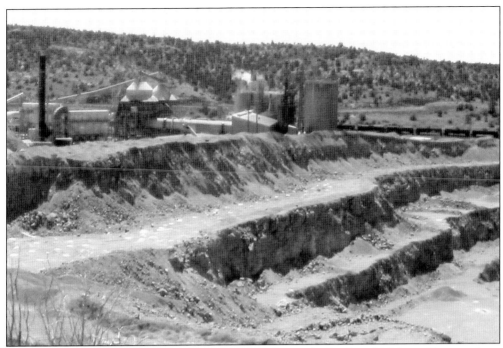

In the far northwest corner of Yavapai County, right on the border of Mohave County, there once was a small town named Nelson. Above, a large lime manufacturing plant sits on the site, but below, nothing remains of the town but a small cemetery.

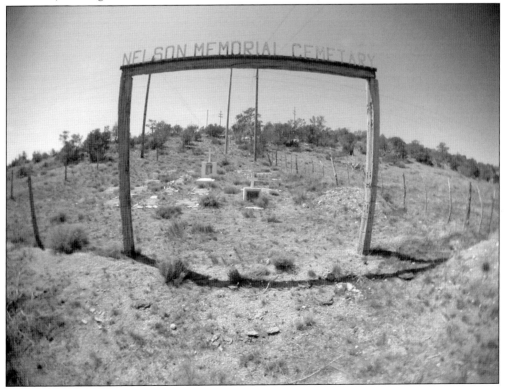

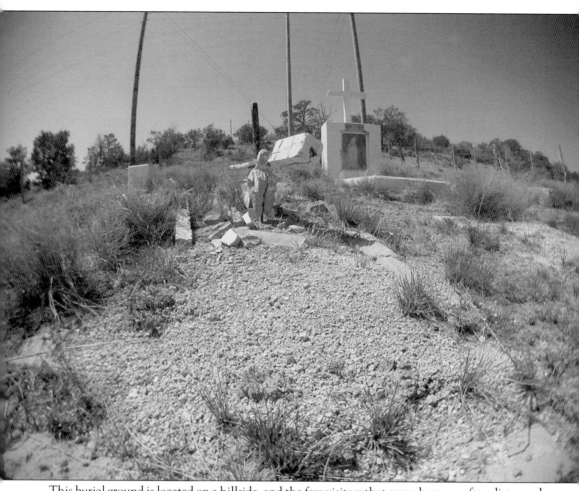

This burial ground is located on a hillside, and the few visitors that come here are often distracted by noise from the lime plant.

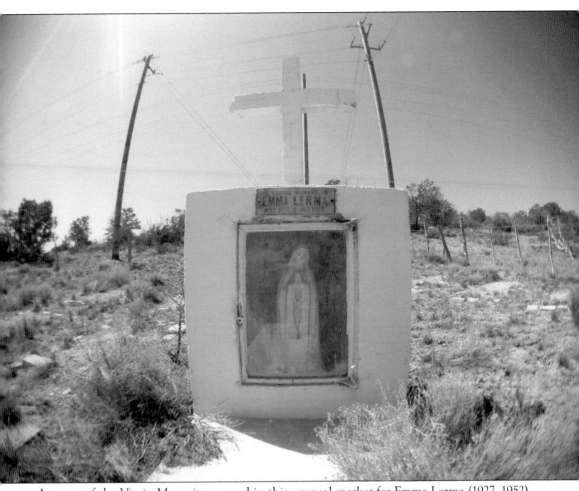

A statue of the Virgin Mary sits encased in this unusual marker for Emma Lerma (1927–1952). Other graves also indicate that the area once had a large Catholic population.

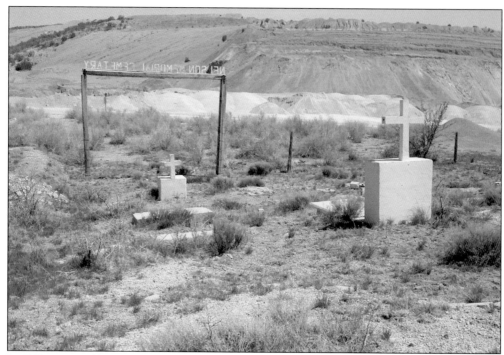

In 1897, a train robbery occurred between Nelson and Peach Springs in Mohave County, perpetrated by the outlaw Fleming "Jim" Parker. His unidentified partner was shot and killed by an express messenger during the robbery and was probably buried unceremoniously in an unmarked grave in this cemetery or nearby. (Courtesy of Lois Schmittinger.)

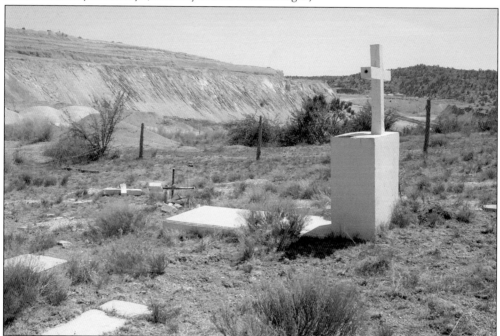

The ravaged hills from the lime plant are a striking contrast to the Nelson Cemetery. (Courtesy of Lois Schmittinger.)

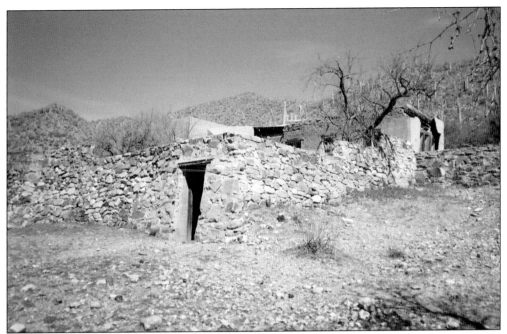

The former mining town of Humbug lies in the far southern region of the Bradshaw Mountains in Yavapai County. The mines closed in 1934, and nothing is left except ruins, which are on private land and should not be visited without permission. A caretaker lives on the site. (Courtesy of Parker Anderson.)

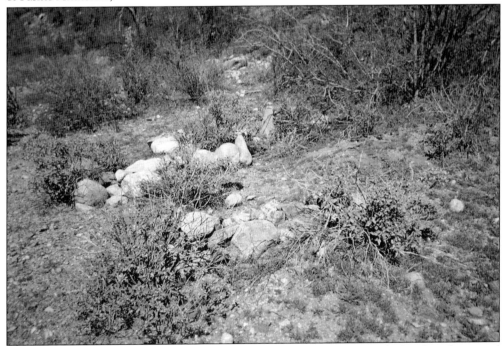

A small cemetery exists outside of the Humbug ruins. Four graves are marked with rocks instead of headstones, although many more of the town's residents are believed to be buried in unmarked graves. (Courtesy of Parker Anderson.)

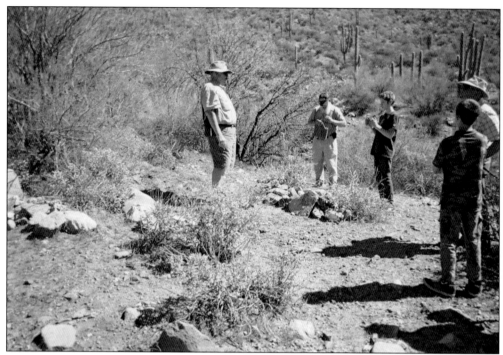

This group visited the Humbug Cemetery on March 2, 2013, when the owners held an open house. Neal Du Shane (center) is pictured addressing the crowd. (Courtesy of Parker Anderson.)

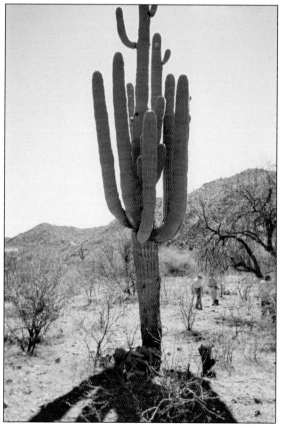

The large pile of rocks underneath this saguaro cactus in Humbug Cemetery is believed to be a grave. (Courtesy of Parker Anderson.)

This is the grave of Newt White, a former caretaker of the Humbug ghost town, who died in 1997. It was his wish to be buried in the Humbug Cemetery, and he certainly is the most recent burial here. (Courtesy of Parker Anderson.)

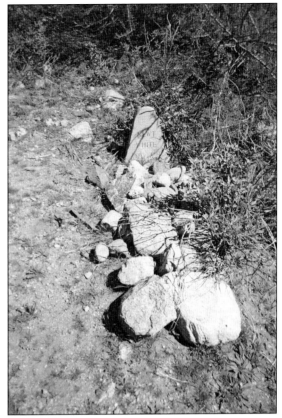

In the southern Bradshaw Mountains, there once was a stagecoach stop operated by Alfred Spence and his wife, Matilda, known as Palace Station. This 1880s photograph of the stop shows Matilda Spence standing in the center. (Courtesy of Sharlot Hall Museum.)

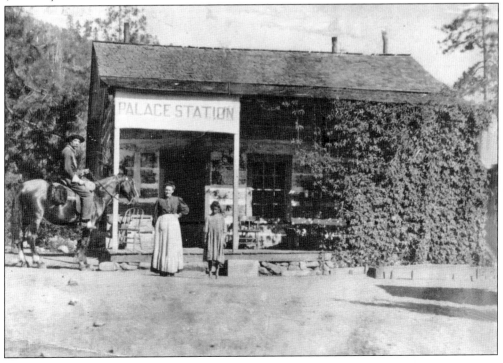

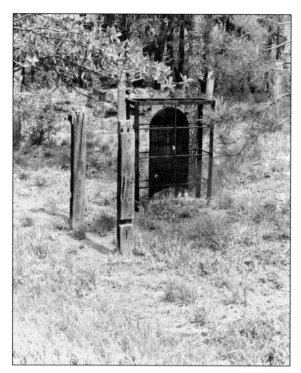

The stage stop had a small cemetery, as most such areas did, since it was often difficult to transport a deceased person into a larger town like Prescott at the time. This undated photograph was probably taken in the 1960s, when Palace Station was already a ghost town. (Courtesy of Sharlot Hall Museum.)

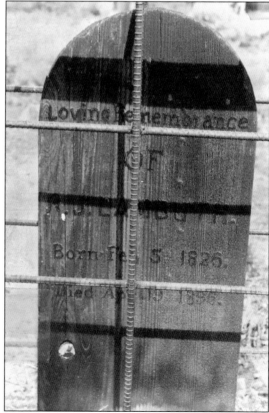

The grave of Richard J. Lambuth (1826–1896), father of Matilda Spence, is seen in this photograph, probably taken in the 1960s. (Courtesy of Sharlot Hall Museum.)

This is the old stage stop as it stands today. The house is now used as quarters for forest rangers, and the site is on private US National Forest land.

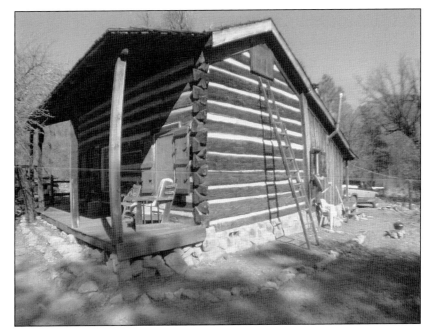

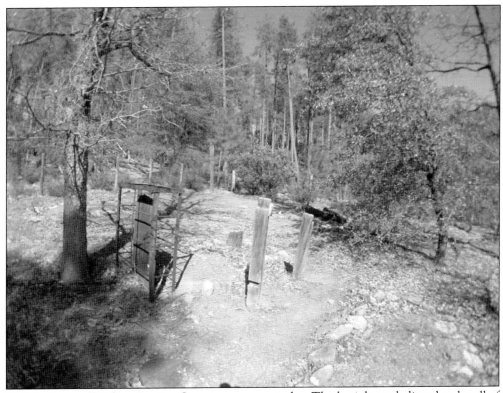

This is the small Palace Station Cemetery as seen today. The burials are believed to be all of Spence family members; it is also believed there have been no burials here since 1903.

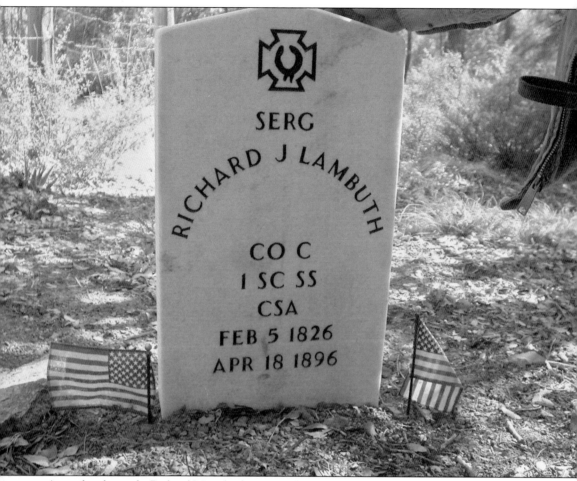

SERG
RICHARD J LAMBUTH
CO C
1 SC SS
CSA
FEB 5 1826
APR 18 1896

A new headstone for Richard J. Lambuth was installed in recent years by Spence family descendants (although his old marker also remains) to commemorate his service in the Confederate army during the Civil War.

Records show who is buried here, but there are very few markers on the graves anymore. The Palace Station burial ground is actually more of a family cemetery than a community graveyard.

DISCOVER THOUSANDS OF LOCAL HISTORY BOOKS
FEATURING MILLIONS OF VINTAGE IMAGES

Arcadia Publishing, the leading local history publisher in the United States, is committed to making history accessible and meaningful through publishing books that celebrate and preserve the heritage of America's people and places.

Find more books like this at
www.arcadiapublishing.com

Search for your hometown history, your old stomping grounds, and even your favorite sports team.